Famous Artists School

How to Draw the Human Figure

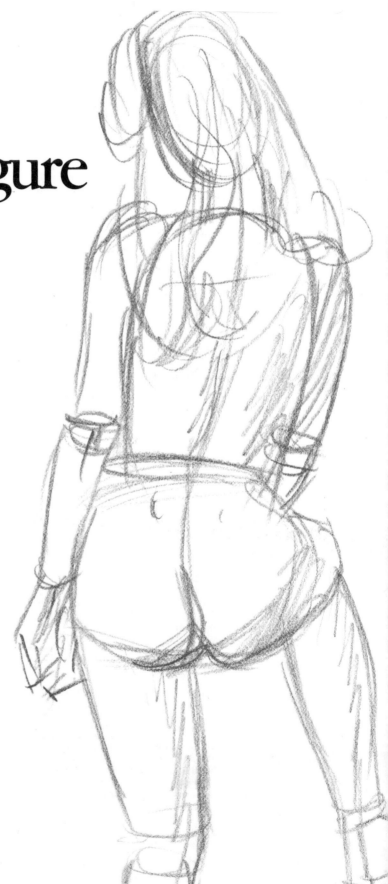

Albert Dorne
In founding the Famous Artists School Albert Dorne turned a dream into a reality. Having been one of the top illustrators in the country for years, Dorne had generously helped and advised many aspiring artists. Founding the School and rounding up the finest art faculty in America enabled him to help many thousands more.

Robert Fawcett
Because of his outstanding mastery of draftsmanship and his highly personal use of color, Robert Fawcett was called "the illustrator's illustrator" early in his successful career. His dazzling technical ability and meticulous skill grew out of total dedication and a determination to settle for nothing short of excellence.

Austin Briggs
More than 75 art awards and five medals from the Society of Illustrators have made Austin Briggs one of the most honored artists of this century. Highly skilled in black and white mediums, Briggs developed into a complete master of design and color—both in illustration and fine art.

Ben Stahl
From the time he won an art school scholarship while in his teens, Ben Stahl has impressed both the public and his fellow artists with the versatility and power of his drawings and paintings. With his generosity of spirit, he has always been glad to use part of his time teaching and inspiring others.

Arnold Blanch
The pictures of Arnold Blanch hang in numerous public collections, including The Library of Congress and The Metropolitan Museum of Art. In addition to having received countless awards and honors, this versatile artist has long been recognized as one of America's great art teachers.

Learn FIGURE DRAWING with the easy-to-follow methods of these FAMOUS ARTISTS!

The Famous Artists School series of books pools the rich talents and knowledge of a group of the most celebrated and successful artists in America. The group includes such artists as Norman Rockwell, Albert Dorne, Ben Stahl, Harold Von Schmidt, and Dong Kingman. The Famous Artists whose work and methods are demonstrated in this volume are shown at left.

The purpose of these books is to teach art to people like you—people who like to draw and paint, and who want to develop their talent and experience with exciting and rewarding results.

Contributing Editor
Howard Munce
Paier College of Art

PUBLISHER'S NOTE
This new series of art instruction books was conceived as an introduction to the rich and detailed materials available in Famous Artists School Courses. These books, with their unique features, could not have been produced without the invaluable contribution of the General Editor, Howell Dodd. The Contributing Editors join me in expressing our deep appreciation for his imagination, his unflagging energy, and his dedication to this project.

Robert E. Livesey, *Publisher*

Famous Artists School

STEP-BY-STEP METHOD

How to Draw the Human Figure

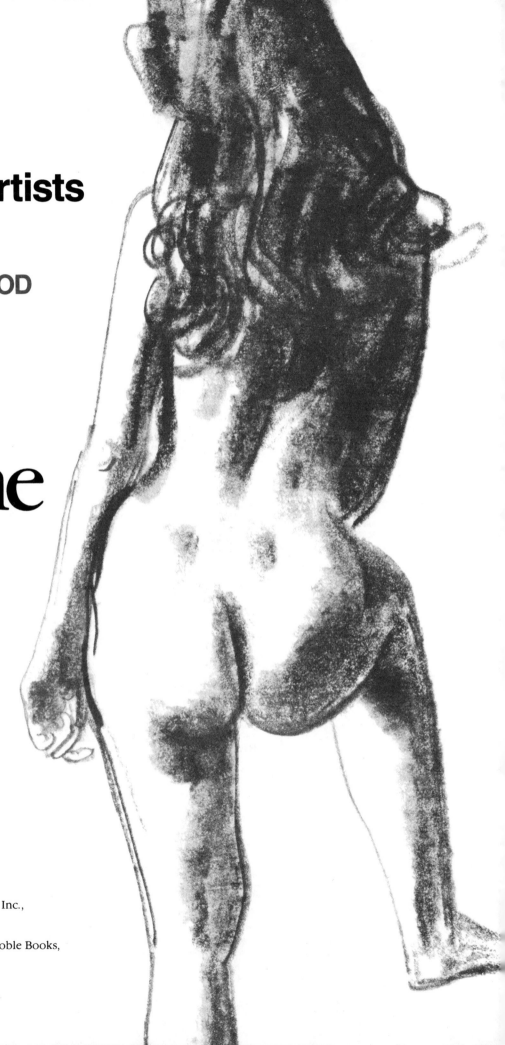

Published by Cortina Learning International, Inc.,
Westport, CT 06880.

 Distributed to the Book Trade by Barnes & Noble Books,
a Division of Harper & Row.

How to Draw the Human Figure
Table of Contents

Copyright © 1983 by Cortina Learning International, Inc.

All Rights Reserved. This material is fully protected under the terms of the Universal Copyright Convention. It is specifically prohibited to reproduce this publication in any form whatsoever, including sound recording, photocopying, or by use of any other electronic reproducing, transmitting or retrieval system. Violaters will be prosecuted to the full extent provided by law.

Printed in the United States of America
9 8 7 6 5 4 3 2 1

ISBN 0-8327-0901-8 ISBN 0-06-464069-8

Designed by Howard Munce

Composition by Typesetting at Wilton, Inc.

Your Practice Projects...*how they teach you*

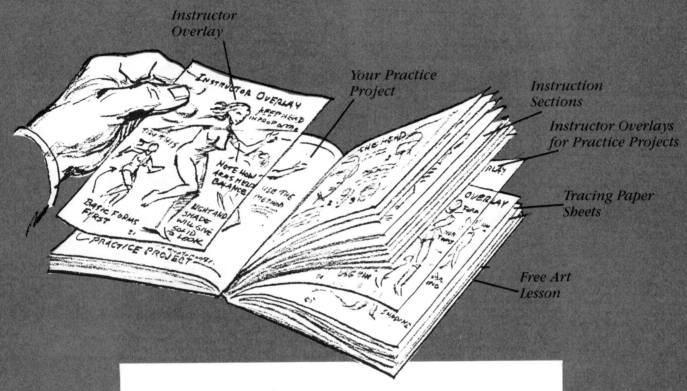

Instructor Overlay

Your Practice Project

Instruction Sections

Instructor Overlays for Practice Projects

Tracing Paper Sheets

Free Art Lesson

The Practice Projects accompanying each new subject give you the opportunity to put into immediate practice what you have just learned.

You can draw directly on the Project pages, using ordinary writing pencils, or take a sheet of tracing paper from the back of the book and place it over the basic outline printed in the Project and make experimental sketches. Also, you can trace the printed outline and transfer it onto any other appropriate paper. (The transfer method is explained on page 80.)

Instructor Demonstrations for the Projects are located in the last section of the book. They are printed on tracing paper overlays. You can remove them and place them either over your work or over white paper so you can study the corrections and suggestions.

Do not paint on Practice Project pages. This would damage the pages and spoil your book. If you wish to paint with watercolors you can obtain appropriate papers or pads at an art supply store. For oil paints you can get canvas, canvasboards or textured paper.

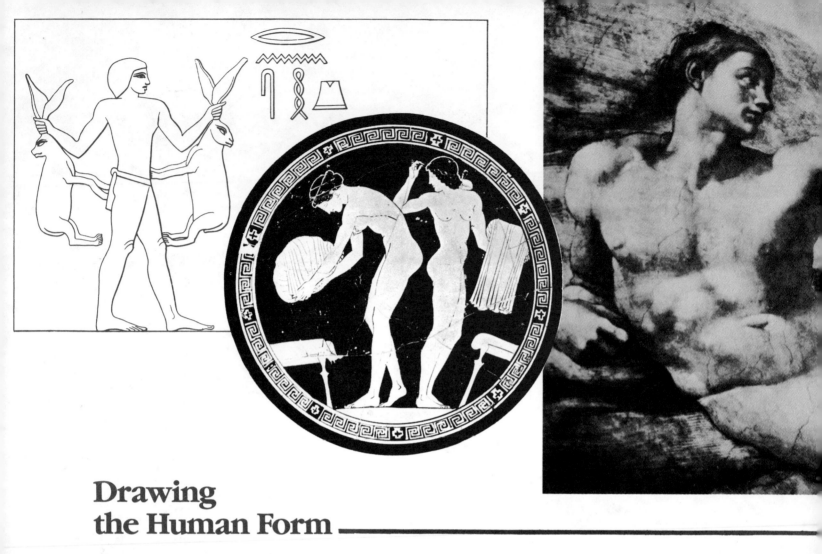

Drawing the Human Form

"The highest object for art," said Michelangelo, master spirit of the Renaissance, "is man." The human figure is one of the most fascinating and rewarding subjects any artist can draw. Glance through any collection of art masterpieces and you will see that through the ages artists have devoted much of their time and talent to portraying the human form.

It's only natural to want to sketch people. What can interest or appeal to us more than the men, women and children who make up the world around us? Whether you draw them realistically or abstractly, in repose or in motion, performing any of the thousands of actions they are capable of, your subjects are always available, and all you need to capture them is a pad and a pencil. For you, the artist, figure drawing holds endless excitement and infinite possibilities for fun and self-expression.

You will often hear it said that figures are difficult to draw. That is true only for inexperienced artists. They are perplexed by details of features, anatomy, and clothing—but only because they have not learned to draw first things first.

The human figure is, first of all, a three-dimensional object; a solid structure of bulk and weight. To draw it convincingly, you must learn how to create the illusion of solid form on your sheet of paper. That is one of the first things we will teach you here.

Drawing on the combined know-how of the distinguished artists who make up the Faculty of Famous Artists School, we give you a thorough understanding of the basic solid form of the human body and how to construct it on paper.

Once you've learned to control the basic form you can approach more subtle and creative interpretations of the human figure with confidence. Step by step we explain the individual parts of the body, such as the head, hands, and feet, and how to draw them in different positions. An elementary knowledge of artistic anatomy is indispensable to the artist, and here we give you the information you need to make every part of your figures anatomically convincing. One of the most important lessons you will learn is that what you leave out is just as important as what you put in, sometimes more so. With the aid of dozens of diagrams, photographs, and how-to drawings, we make the movements of the body and its parts easy to understand, so you can draw them with the sureness that comes only from solid knowledge. Among the

6

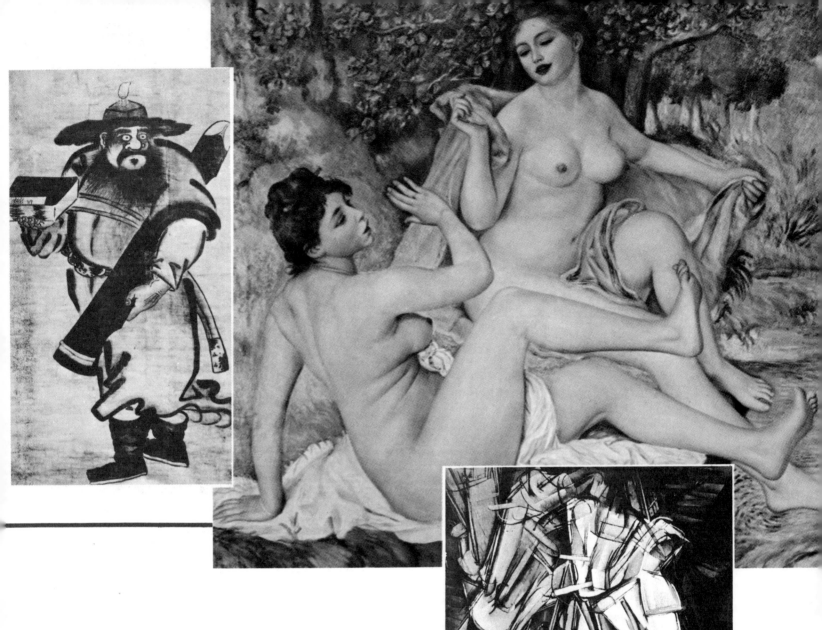

other valuable secrets we teach you is how to give
the figure naturalness and vitality by making gesture
drawings. Throughout, these pages are illustrated
with apt examples from the work of members of the
Famous Artists Faculty and other celebrated artists.

Drawing the figure is a joy that can add richness
to your spare moments and your holidays. It will
sharpen your observation so that you will become
aware of many new facets of the human form and its
movement. Not only will it enhance your appreciation
of good art, but with continued practice and study it
can help you develop into the skilled figure artist you
want to be.

7

Working Tools

Because this book is devoted to learning to draw the figure, we shall mostly limit our working materials to classic drawing tools: the pencil, charcoal and pastel. All are black at their most intense and allow for a variety of gray shades to model with—hence, each is ideal for the purposes we shall deal in.

The pencil

You and pencils are old friends. You have been writing with them since childhood. Drawing pencils come in a variety of leads, ranging from very soft (6B) to very hard (9H) but you can get excellent results with regular writing pencils which come in grades of soft, medium and hard. The softer the pencil the thicker the lead—and therefore the broader the line you can draw with it. The harder the pencil the grayer the line it makes. Because hard pencils are likely to dig into your paper when you apply pressure, you should use a softer one when you want darker, richer lines.

The best way to get to know the diversity of tones and effects that can be achieved with these different leads is to use them and see for yourself.

A regular pencil sharpener will give you a sharp, even point suitable for much of your drawing. If you prefer, you can sharpen your pencil with a single-edge razor blade and finish by shaping the point on a sandpaper pad, or fine-grained sandpaper from your workshop or hardware store. To get a chisel point, useful for making broad strokes, first sharpen a soft pencil with a razor blade, and then rub it on the sandpaper without rolling it.

Hold your pencil any way you find comfortable. The writing grip is a good position for carefully controlled lines and details.

The under-the-palm grip is good for working larger or more freely as when sketching outlines or shading.

Charcoal

This wonderfully responsive medium comes in three forms.
First, there is the natural charred stick commonly called
"vine charcoal." Then there are two synthetic forms.
One is made into a pencil and the other comes as a
chalk about 3 inches long. All three forms come in
varied degrees of softness (blackness). Natural
charcoal is the most subtle and it erases most
easily, using a kneaded eraser. The pencil
kind is the least brittle and cleanest
to handle.

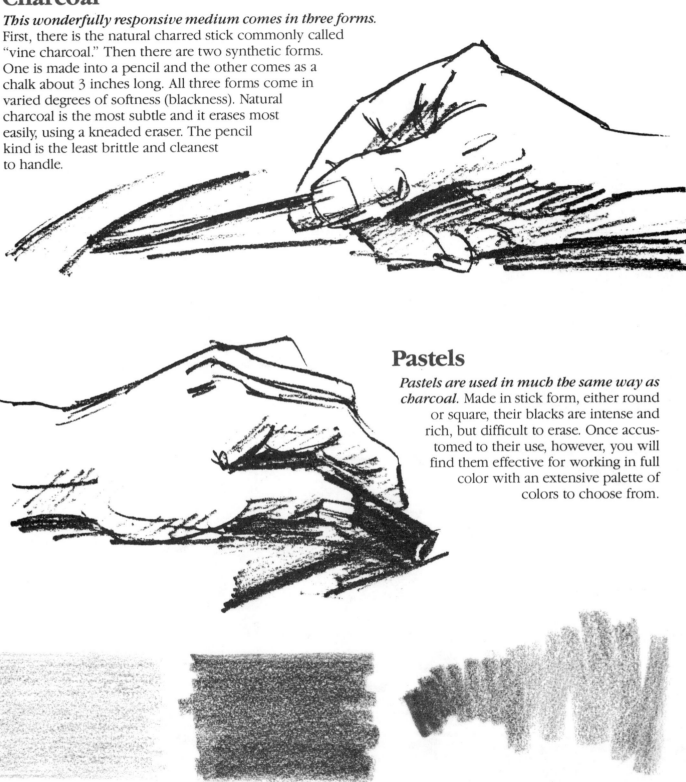

Pastels

***Pastels are used in much the same way as
charcoal.*** Made in stick form, either round
or square, their blacks are intense and
rich, but difficult to erase. Once accus-
tomed to their use, however, you will
find them effective for working in full
color with an extensive palette of
colors to choose from.

Flat, even effects are made here with smooth, even, horizontal
strokes with a medium pencil or a soft pencil.

Vigorous up-and-down strokes are made here with the side of
a soft pencil. Increased pressure gives a darker tone.

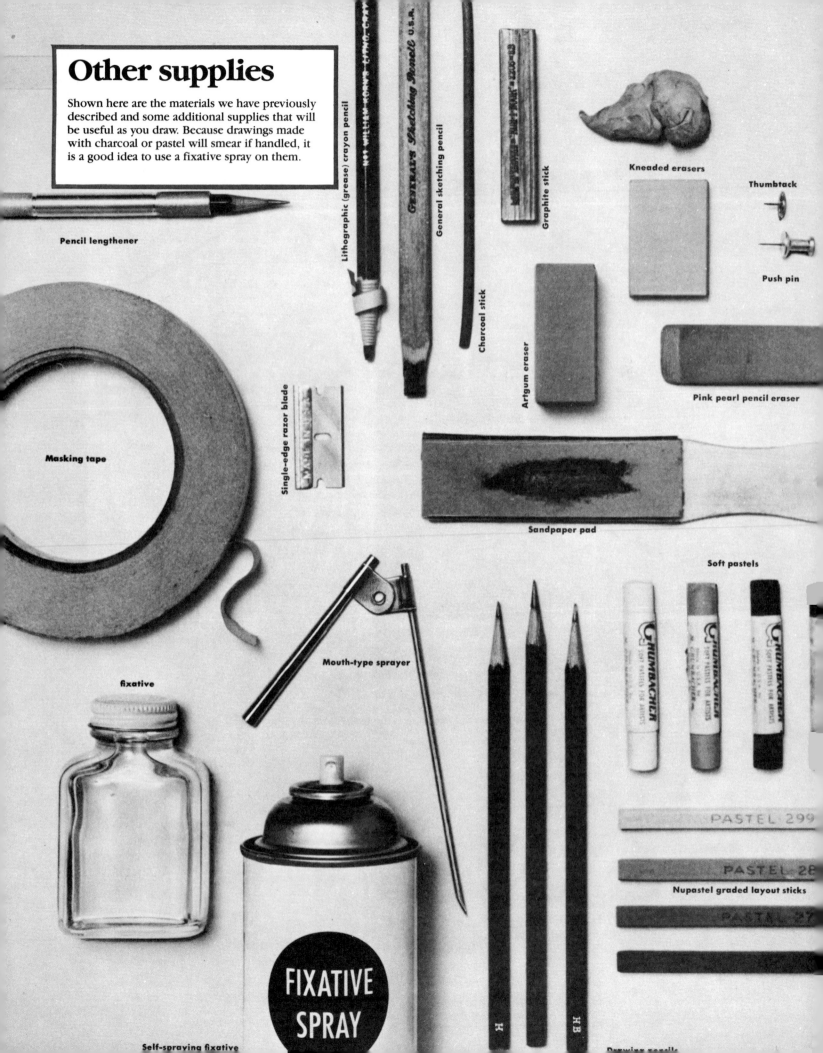

Other supplies

Shown here are the materials we have previously described and some additional supplies that will be useful as you draw. Because drawings made with charcoal or pastel will smear if handled, it is a good idea to use a fixative spray on them.

Pencil lengthener

Lithographic (grease) crayon pencil

General sketching pencil

Graphite stick

Charcoal stick

Kneaded erasers

Thumbtack

Push pin

Artgum eraser

Pink pearl pencil eraser

Single-edge razor blade

Masking tape

Sandpaper pad

Soft pastels

Mouth-type sprayer

fixative

PASTEL 299

PASTEL 28

Nupastel graded layout sticks

PASTEL 27

FIXATIVE SPRAY

Self-spraying fixative

Drawing pencils

Erasing

A medium soft eraser such as a pink pearl or the eraser at the end of a writing pencil is good for most erasures. Another useful type is a kneaded eraser which can be shaped to a point by squeezing it between your finger tips. If you wish to remove a really dark area in a pencil drawing, you can lightly press a piece of Scotch tape onto the area and lift most of the pencil marks. Then, use a regular eraser to remove the rest. This way, you won't smear the dark strokes.

Papers and Drawing Boards

Artists are inveterate experimenters. They never cease trying new materials and combinations of materials. Most often, this concerns the stuff on which drawing is done —paper. Near the end of this book you'll find a supply of drawing paper for your Practice Projects. For additional practice sketching, typewriter paper is good. Also, a pad of common newsprint is inexpensive and good for sketching. It can be purchased at a store that sells art supplies. Another good type of practice paper is a roll of commercial white wrapping paper, but be sure it is not the kind with a wax surface.

Remember that papers have different surfaces —slick, average or rough (artists refer to the latter as having "tooth"). Each type will cause the drawing to produce different effects. Experiment to discover your favorite combinations. An easel is fine, but if you don't have one, you can work on a light, firm board—⅛" plywood, masonite or other construction board will be a good support to draw on. Fasten your paper to the board with masking tape, thumbtacks or pushpins and put a piece of smooth cardboard or several thicknesses of paper under your top sheet, so rough or uneven spots on the board won't interfere with your drawing. You can then prop the board in your lap and either hold the top with your outstretched arm or lean it against the edge of a table. Another method is to prop the board on the seat of a straight-backed chair. The seat makes a good place to hold pencils and erasers.

Models... *and where to find them*

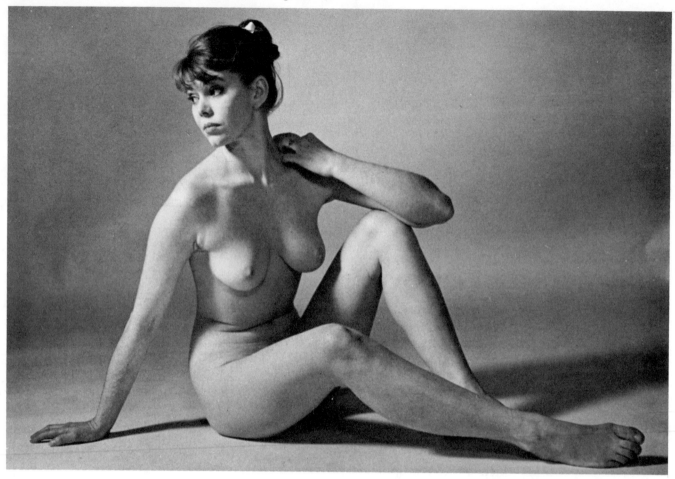

Obviously, the most efficient way to study and draw the undraped figure is to have a person pose, nude and motionless before you.

The optimum way to do that is to retain a professional model, either privately or in concert with a group of other interested artists, to form a sketch class—thereby reducing the model's fee.

Organized sketch classes usually exist in most communities of any size; check your local art supply store to see if they have listings for one. Also, see your Yellow Pages under "Models" to inquire if they pose for existing groups.

It's important at the beginning of your study of the male or female figure that you be able to see the body, and its construction, unencumbered by clothes. A model in a plain bathing suit or tight trunks is the next best thing to the nude—also that will often open the possibility of having friends or family pose for you without embarrassment.

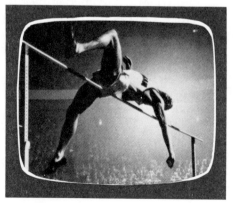

Life class in your own home

Never before has the artist had so unique an opportunity to observe the human family in all its fascinating variety. No matter where you live, right in your own home you can see and study types and characters from all over the world—on the screen of your television set. With a sketch pad and pencil, seated before your screen, you can make quick sketches and notes of the actions and characteristics of the hundreds of personalities who parade before you, in every conceivable role and activity.

Photographs can also be useful

Working from live models (even yourself in the mirror) is desirable, but there is also recourse to good photographs: those you take yourself, dictating the pose you want, or those you find in magazines. Nudist, physical culture and sports publications are excellent sources. Photos of swimming and track events are good. Basketball shots show figures running, leaping and flailing, and boxing photos allow you to study crouching poses with muscles under tension.

Magazines are rich in photographic material to draw from and good figure poses abound.

Photos of all sporting events, from skiing to swimming, not only provide valuable anatomical information, but also show figures in a wide range of body actions.

Gesture Drawing...*a natural way to draw*

There is no more oft-quoted axiom in art instruction than "To learn to draw you must first learn *to see*." And a most effective way to do that is to endlessly indulge in quick gesture sketches and to "see" with spontaneity and verve. Such qualities, of course, involve more than the use of your eyes.

The essence of a gesture, whether you are performing it or drawing it, is to first *feel it*. For example, stand up, spread your feet! Thrust your fist into the air! That's a dramatic gesture, and you can feel it up your back and out your arm.

If someone else were doing it and you were doing a quick sketch of it, you'd feel the sweep and you'd slash an arc from the ground towards the sky.

And if you suddenly went from that gesture to bending your back and touching your foot with your opposite hand, you'd be *creating and feeling* a totally different gesture; across and down into a swooping curve.

That's the frame of mind you should bring to a stimulating work-out

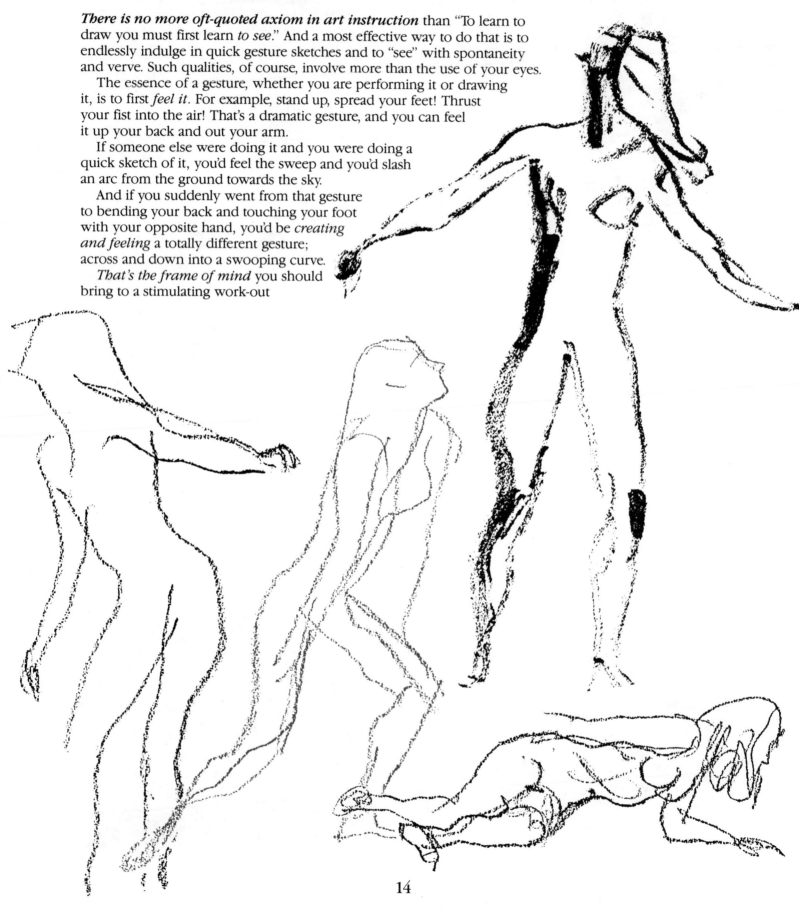

14

of rapid gesture exercises that shouldn't last longer than five seconds to three or four minutes. That's enough time for your eye to encompass, your sensibilities to respond and your arm and hand to perform the act of transforming a human gesture onto paper.

And when the model changes without warning, to a totally different pose, you should change too—a new observation—a new mood and on to dozens of successive sketches—always following the dictum of the legendary instructor, Kimon Nicolaides, "Don't draw what the thing is, draw what it's *doing*." This is not only the most natural way to learn to draw the figure, but it's also the most stimulating.

In gesture drawing, learn to use your entire arm, not just your fingers and wrist. Let your arm swing and guide your hand as you freely move through the whole figure. Go from one end of the body to the other, constantly letting your lines cross and cover each other, almost without taking your pencil from the paper. You will be producing *purposeful scribbling*.

Understand that gesture drawings are not an end in themselves, but an approach. Their spirit and dash, their inner feeling and instant recognition of what's "doing" will carry over into your more finished art work.

Load up on paper, and go to it!

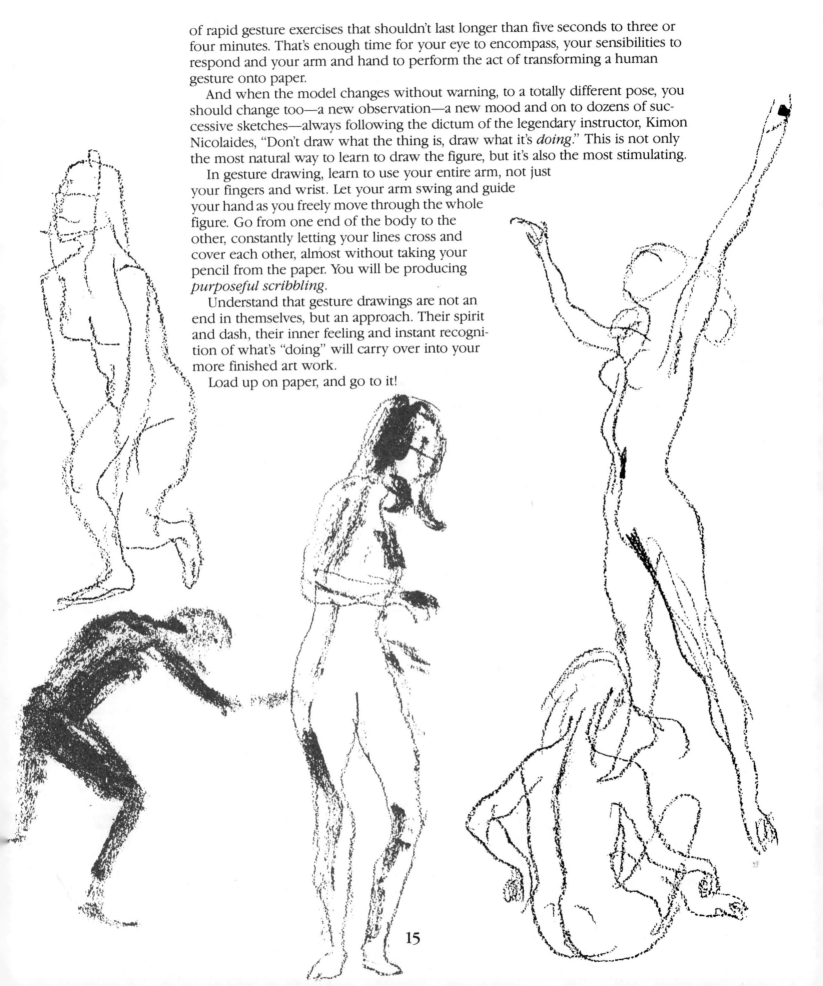

15

The importance of gesture
... it cannot be emphasized too strongly

An artist's definition of gesture should include such words as movement, pose, attitude, and purpose. In fact, gesture drawing means more than just expressing the action of a figure. It has to do with capturing the inner meaning, the essence of the subject, and what is happening at that moment.

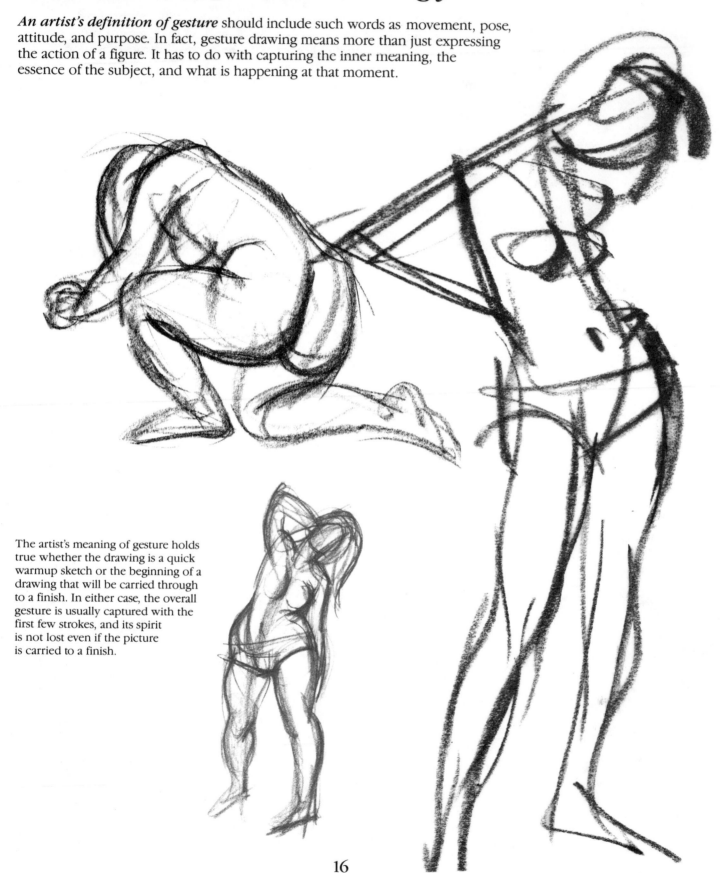

The artist's meaning of gesture holds true whether the drawing is a quick warmup sketch or the beginning of a drawing that will be carried through to a finish. In either case, the overall gesture is usually captured with the first few strokes, and its spirit is not lost even if the picture is carried to a finish.

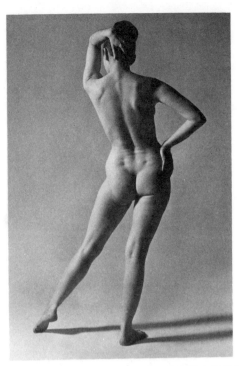

Figure drawing... *step by step*

Here are three stages in the development of a figure drawing by Austin Briggs, one of the founders of Famous Artists School. The model was the girl in the photograph at the left. Before he started to draw, Briggs carefully observed the pose, the *gesture* and the basic action of the figure.

1 As he began to draw, the artist concentrated his first effort on the simple lines that suggested the gesture—the angle of the shoulders, the thrust of the hip, the curve of the spine, the position of the legs supporting the weight—and indicated these simply, quickly, and decisively.

2 In Step 2, he began to develop the solid form of the figure and indicated the shadow side with tone.

3 In the third stage, Briggs strengthened the total drawing to emphasize the gesture as well as the form. Finally, he added the refinements that completed the drawing.

Austin Briggs

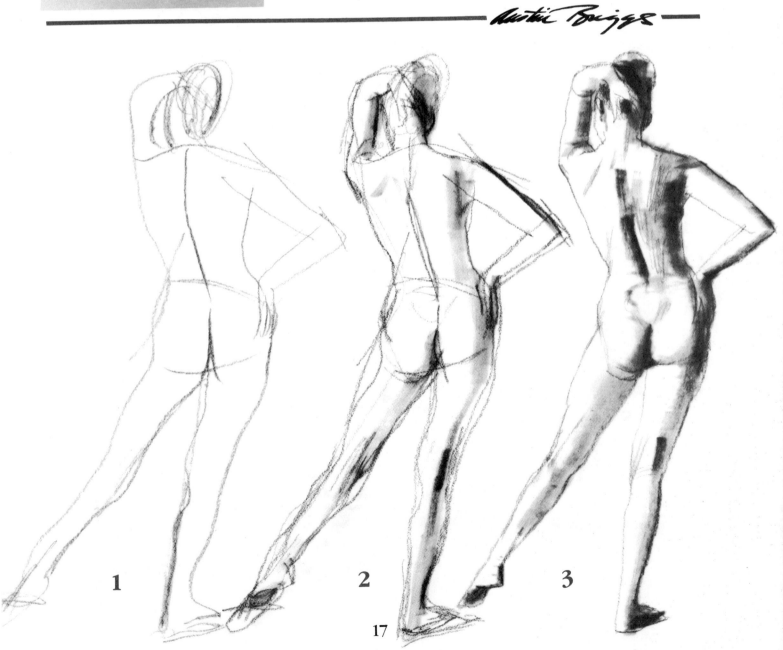

1 2 3

Rhythms...*and counter rhythms*

Look for and emphasize large, rhythmical movements in the figure. Notice that the movements tend to occur in alternating, interlocking sequences, as indicated by the arrows that accompany the drawings on these pages. The major rhythms have been emphasized here, but if you look closely at your model you will see the same interlocking pattern in the minor forms of the legs, arms, and torso.

As you begin your gesture drawing, establish an important movement in the body with free, flowing lines. Then immediately look for an opposing, or counter, rhythm to the first. Once you've added this to your drawing, continue the search for supporting rhythms.

Draw freely, moving your whole arm, and don't be afraid to work large. Remember, you're not trying to make pretty drawings—this is an exercise.

In the drawing at the right, a major rhythm is started by the strong right-to-left thrust of the torso. It is continued by the opposing thrust of the pelvis, while a supporting movement is created by the raised position of the arms.

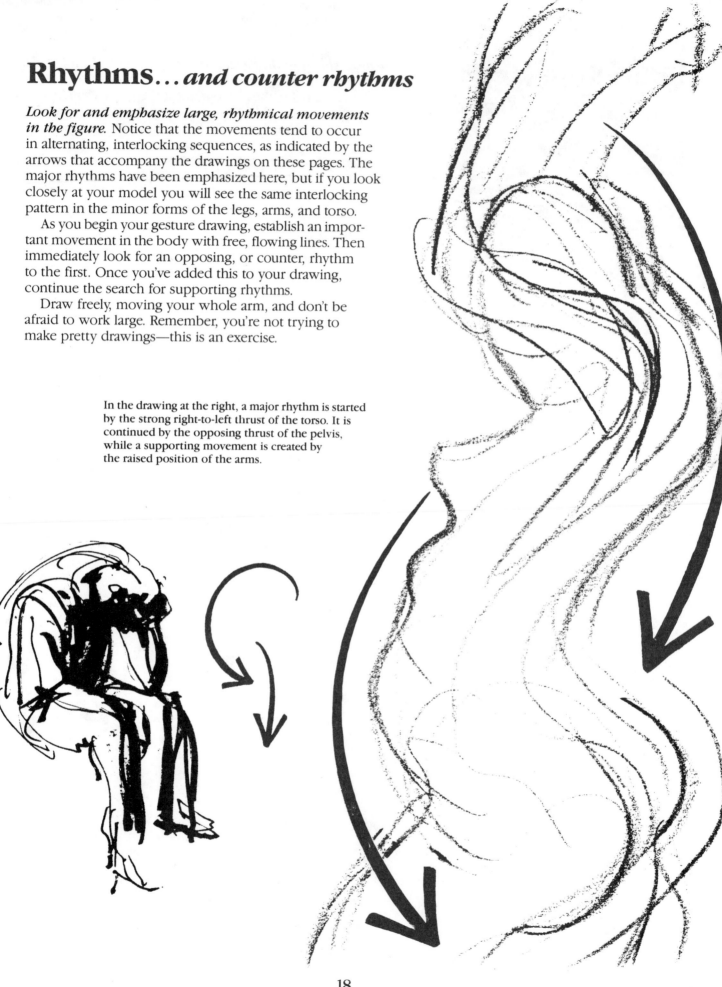

Draw repeated movement

Start off doing gesture sketches with a time limit. Speed is the key here! Allow five seconds to catch a fleeting impression of each pose your model takes. You'll barely have time to indicate every part of the body. After you've made many of these very brief sketches, give yourself a little more time—about ten to fifteen seconds. Have the model take the same poses. Notice now that although the figure begins to emerge more clearly, the essential gesture is the same as suggested in the five-second sketches.

Slavish copying of the figure is not really drawing; "absolute resemblance" can be uncreative and static. As a creator, the artist must seek out and emphasize those qualities which best spark aliveness: rhythm, balance and movement. He has license to strengthen the rhythm, the flow of lines, to change curves and angles to make a design of his own. He can control balance and inject movement until he feels confident that his figures do have that magic that makes them live.

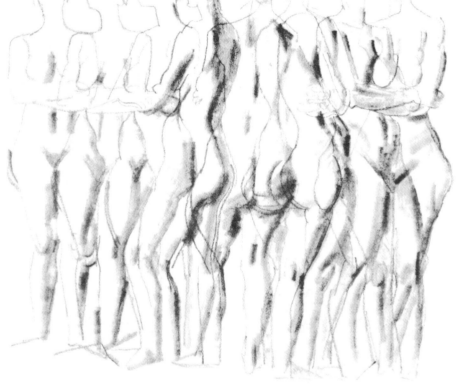

Look at Robert Fawcett's drawings here and see how he has made use of these contrasts to bring grace to each figure—though they were recorded in seconds. As you approach your work, remember that you have the freedom, too, to emphasize or modify these elements which make good design, which make your figures transcend diagrams and spring alive.

Have your model perform some simple action—even just bending over, then standing up straight, again and again. Keep drawing the repeated action over and over. Your lines will build up and your drawn figures will have real movement.

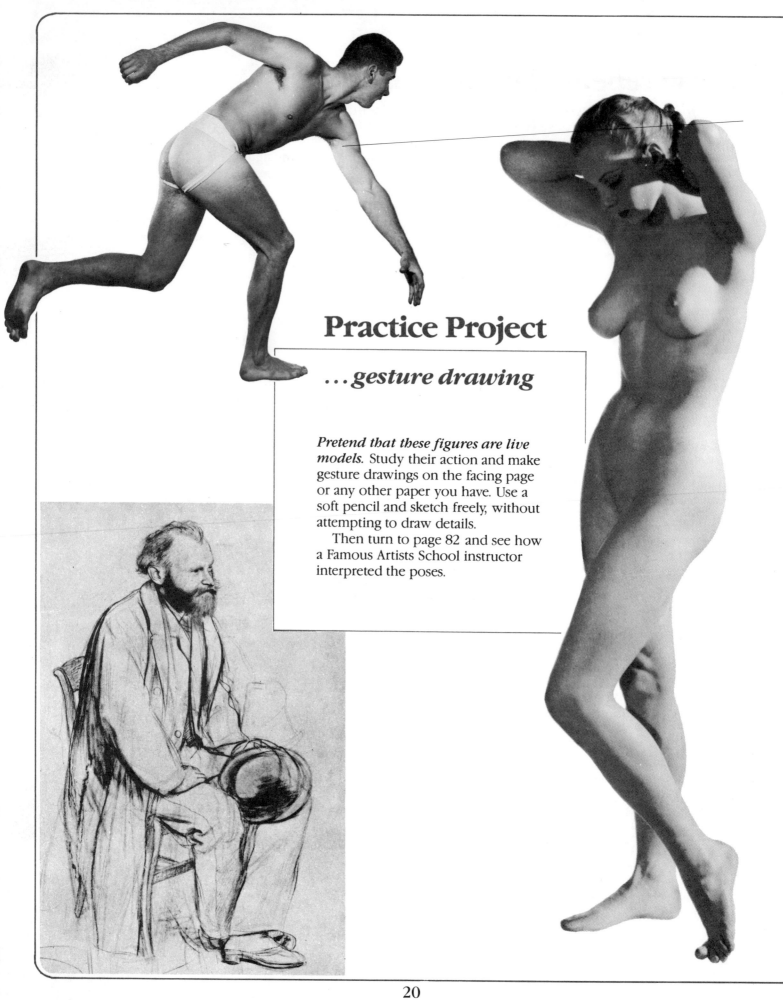

Practice Project

...gesture drawing

Pretend that these figures are live models. Study their action and make gesture drawings on the facing page or any other paper you have. Use a soft pencil and sketch freely, without attempting to draw details.

Then turn to page 82 and see how a Famous Artists School instructor interpreted the poses.

Section 2
The Basic Forms

The vigorous drawing on the right shows you the simple basic forms that make up the larger form of the human body. These are the head and neck; upper torso and lower torso; upper arms, lower arms and hands; upper legs, lower legs and feet. Think of each form as if it were carved out of something solid. Remember that form has three dimensions and that it occupies space.

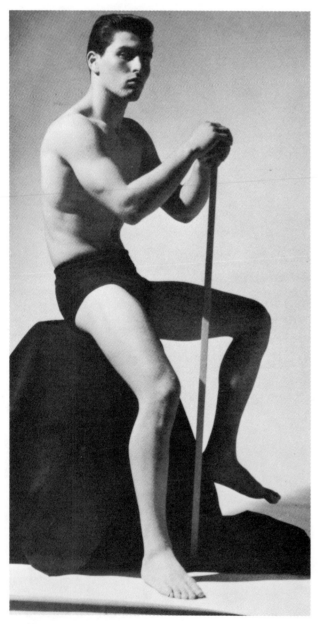

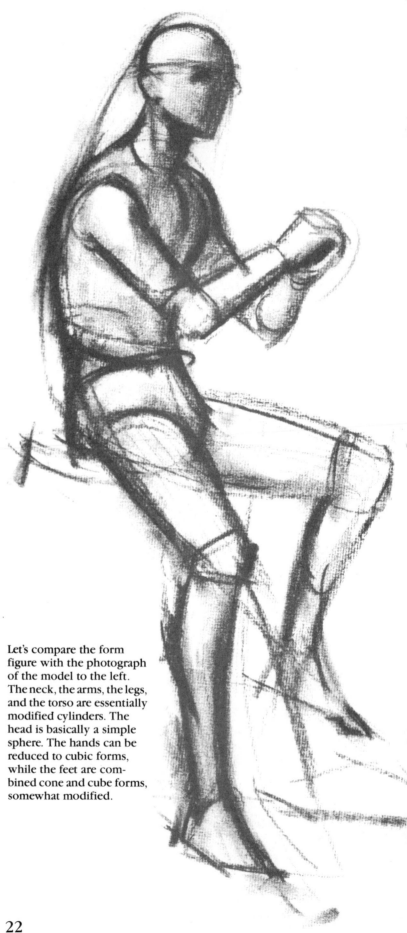

Let's compare the form figure with the photograph of the model to the left. The neck, the arms, the legs, and the torso are essentially modified cylinders. The head is basically a simple sphere. The hands can be reduced to cubic forms, while the feet are combined cone and cube forms, somewhat modified.

22

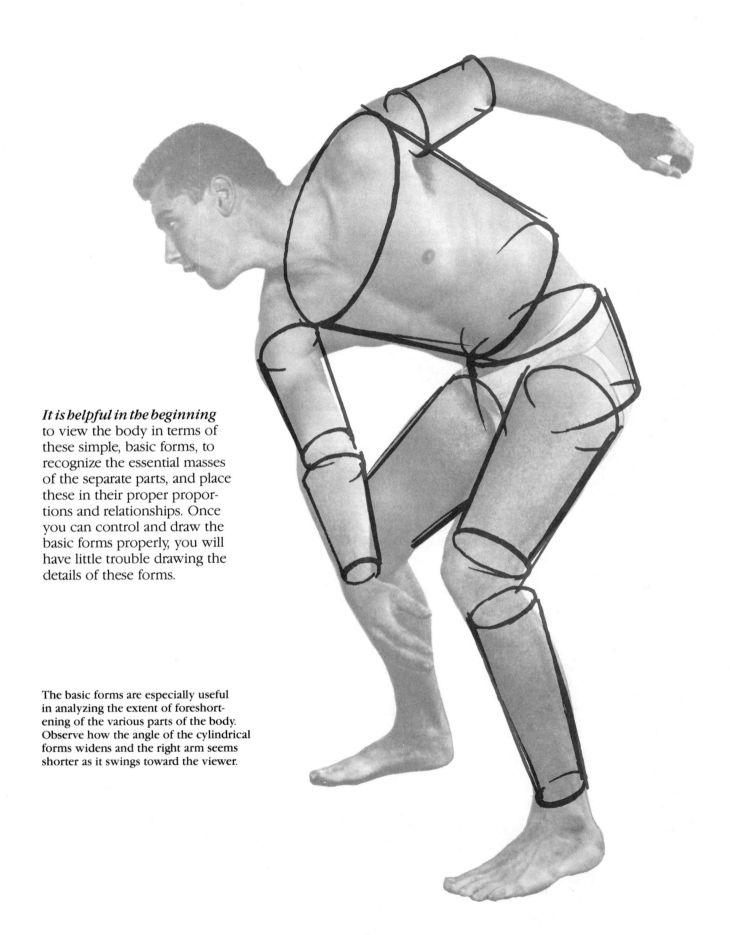

It is helpful in the beginning to view the body in terms of these simple, basic forms, to recognize the essential masses of the separate parts, and place these in their proper proportions and relationships. Once you can control and draw the basic forms properly, you will have little trouble drawing the details of these forms.

The basic forms are especially useful in analyzing the extent of foreshortening of the various parts of the body. Observe how the angle of the cylindrical forms widens and the right arm seems shorter as it swings toward the viewer.

Construction of the figure...

The device of using a manikin is employed here to help you understand the basic forms of the figure for the simple units they are. It's easier, in the beginning, to understand "wooden people" than it is to deal with personality, looks and physique. Besides, our whittled woman never moves and never needs a rest period or a fee.

Another advantage of viewing the figure this way is that you can readily visualize the three-dimensionality of the separate forms better than you can on a human whose skin covers all clues.

The arms and legs are cylinders. The head is a sphere resting on the cylinder of the neck. The torso is separated in two parts, both cylindrical. The separation at the waist is important in helping to establish convincing action. Turn the figure around and you have a front view of the same three-dimensional geometric forms. Notice that the direction of the form is now reversed. The leg that thurst away from us in space now comes toward us. Note the photograph of the curvacious nude model. She's graceful and beautiful, but see how her muscles and curves obscure the basic forms that the crude manikin reveals so clearly.

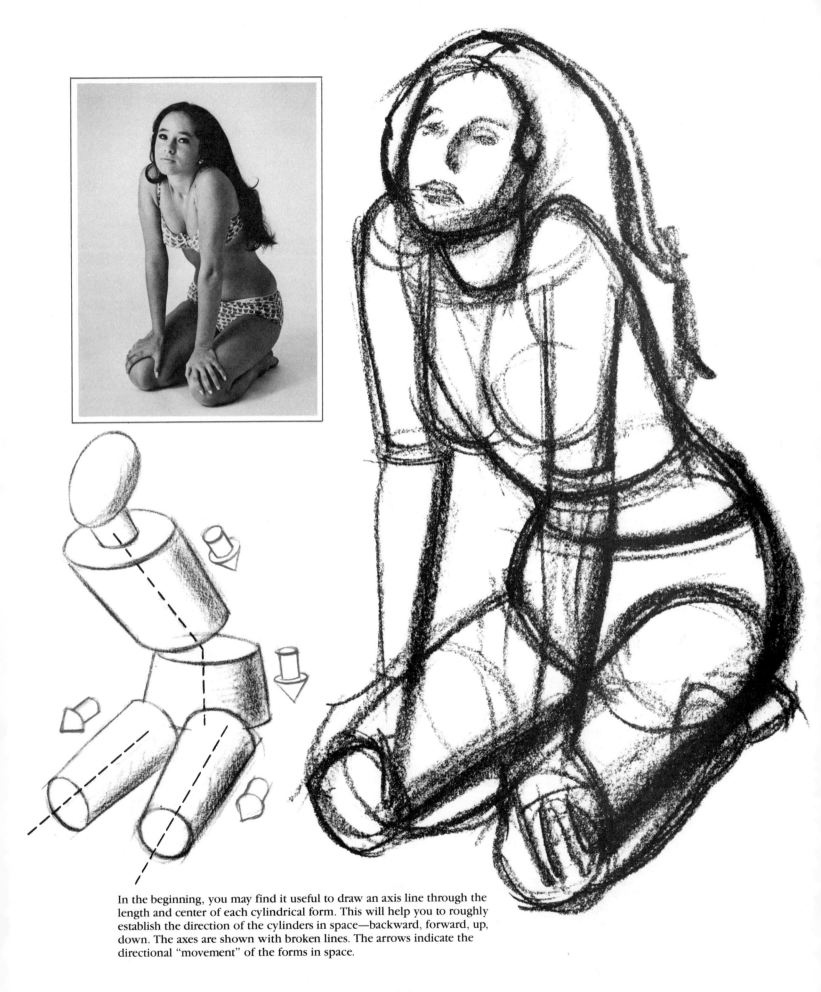

In the beginning, you may find it useful to draw an axis line through the length and center of each cylindrical form. This will help you to roughly establish the direction of the cylinders in space—backward, forward, up, down. The axes are shown with broken lines. The arrows indicate the directional "movement" of the forms in space.

Since the purpose of gesture drawing is to freely and instantly capture an impression of what the model *is doing* rather than *how it's made*, one must then build into that exuberant sketch the engineering that holds it together and allows it to function.

Begin by doing a spirited gesture drawing; then, on a sheet of tracing paper placed over your gesture drawing, draw the basic forms.

Feel out and build up the solid cylinders of the torso, arms, legs and head.

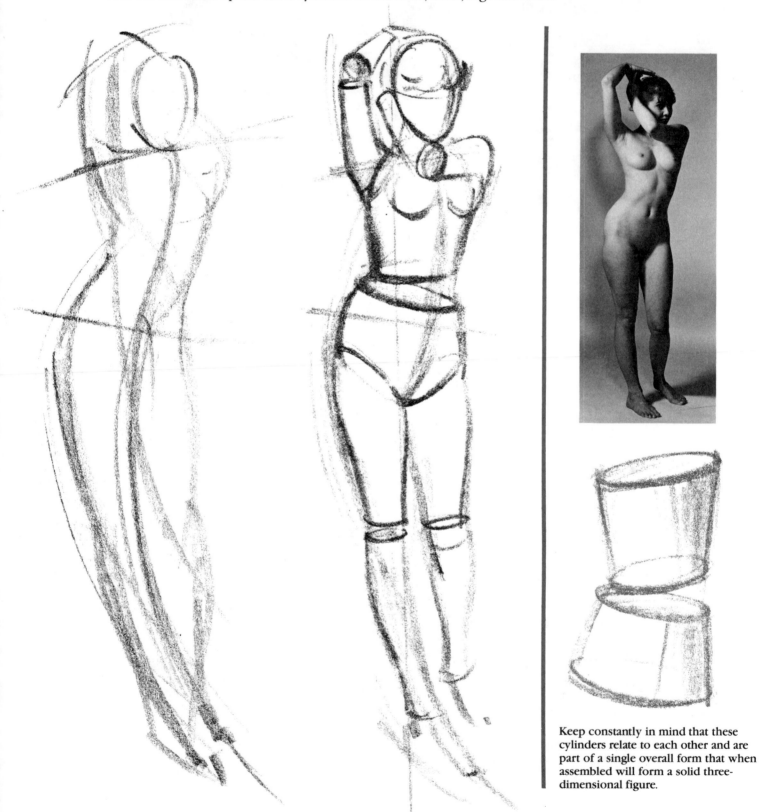

Keep constantly in mind that these cylinders relate to each other and are part of a single overall form that when assembled will form a solid three-dimensional figure.

26

Developing the form figure from the gesture drawing

Foreshortened figures are not easy to draw, since many parts of the body recede from the eye or come forward at an extreme angle. Building a basic figure over the initial gesture drawing is an effective way to work out the construction of a foreshortened pose. These simpler forms are much easier to visualize—and draw—than the complex anatomy of the figure we see in the photo.

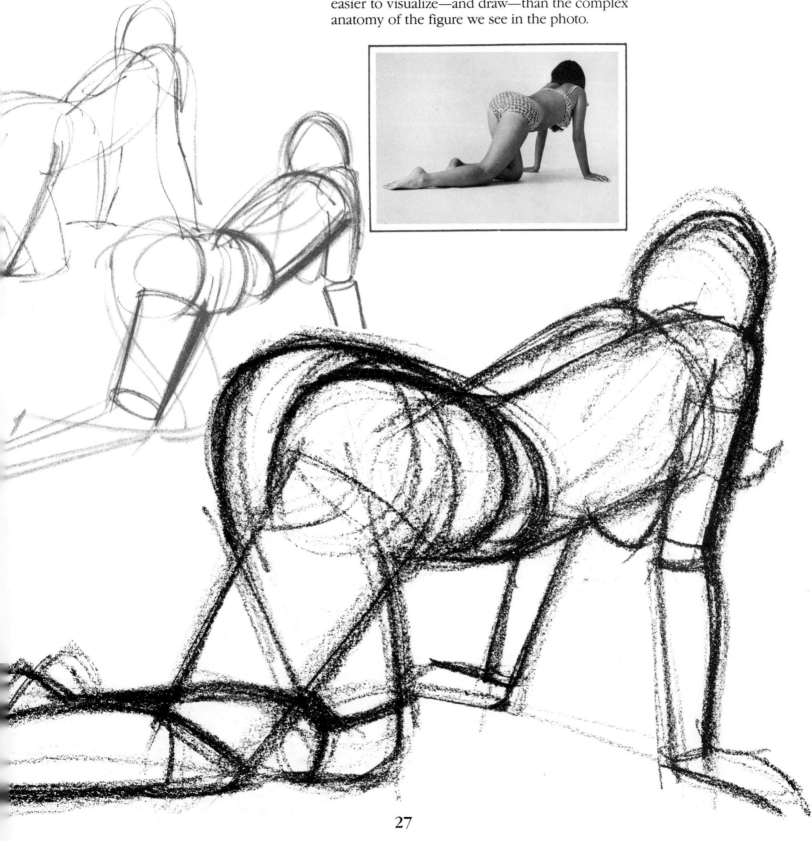

Practical Uses of the Basic Form Figure

Now that you've drawn the basic form cylinders over a gesture drawing, try doing something a little different.

Start with a photo of a person as nearly nude as you can find. Study it. Then make a drawing alongside the photo using only cylinders to express the forms and the proportions.

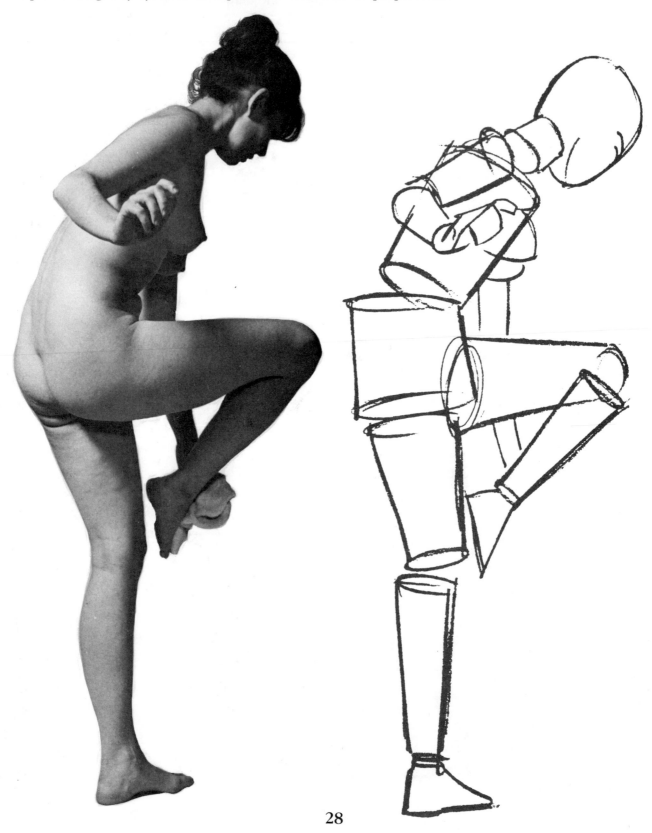

Don't imitate the lighting or shadow patterns of the model. Do line shapes using a soft pencil and drawing freely and searchingly. Build the logical construction in the same way you would if you were joining shapes of clay.

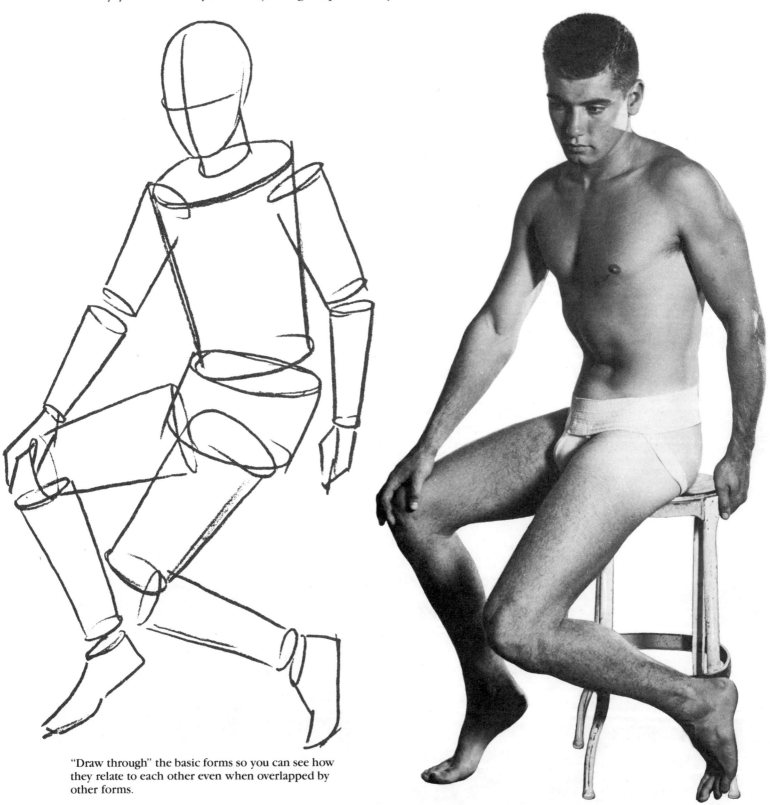

"Draw through" the basic forms so you can see how they relate to each other even when overlapped by other forms.

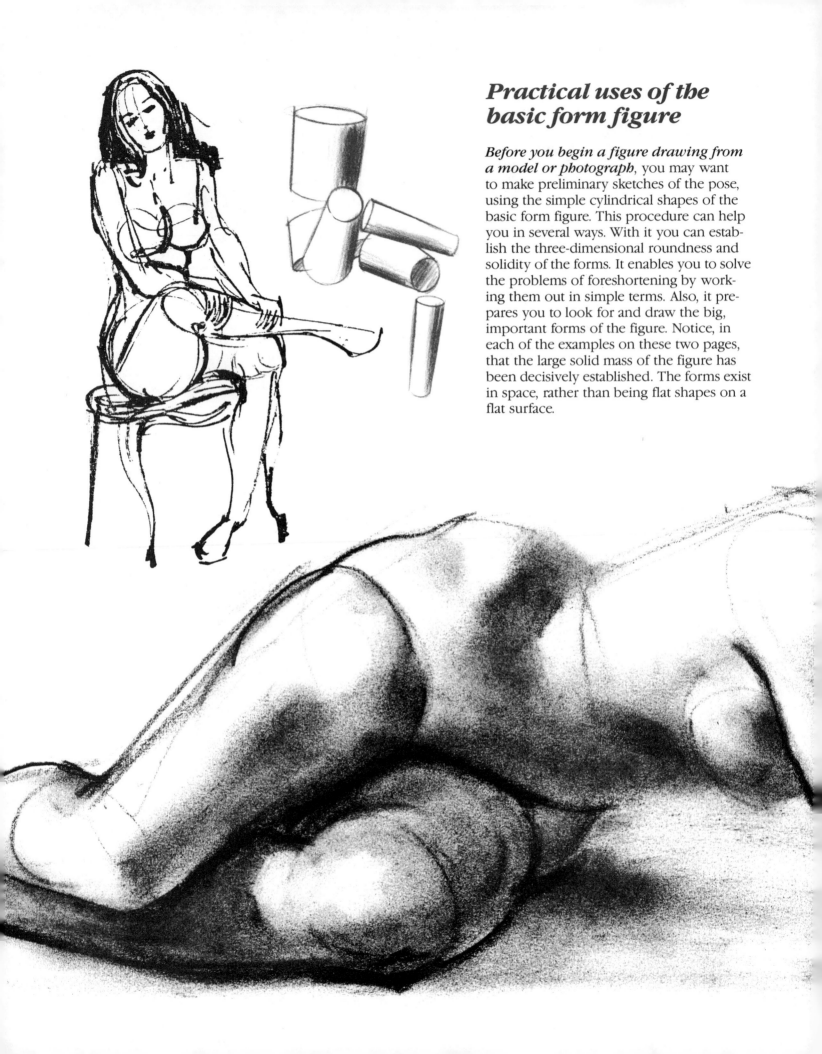

Practical uses of the basic form figure

Before you begin a figure drawing from a model or photograph, you may want to make preliminary sketches of the pose, using the simple cylindrical shapes of the basic form figure. This procedure can help you in several ways. With it you can establish the three-dimensional roundness and solidity of the forms. It enables you to solve the problems of foreshortening by working them out in simple terms. Also, it prepares you to look for and draw the big, important forms of the figure. Notice, in each of the examples on these two pages, that the large solid mass of the figure has been decisively established. The forms exist in space, rather than being flat shapes on a flat surface.

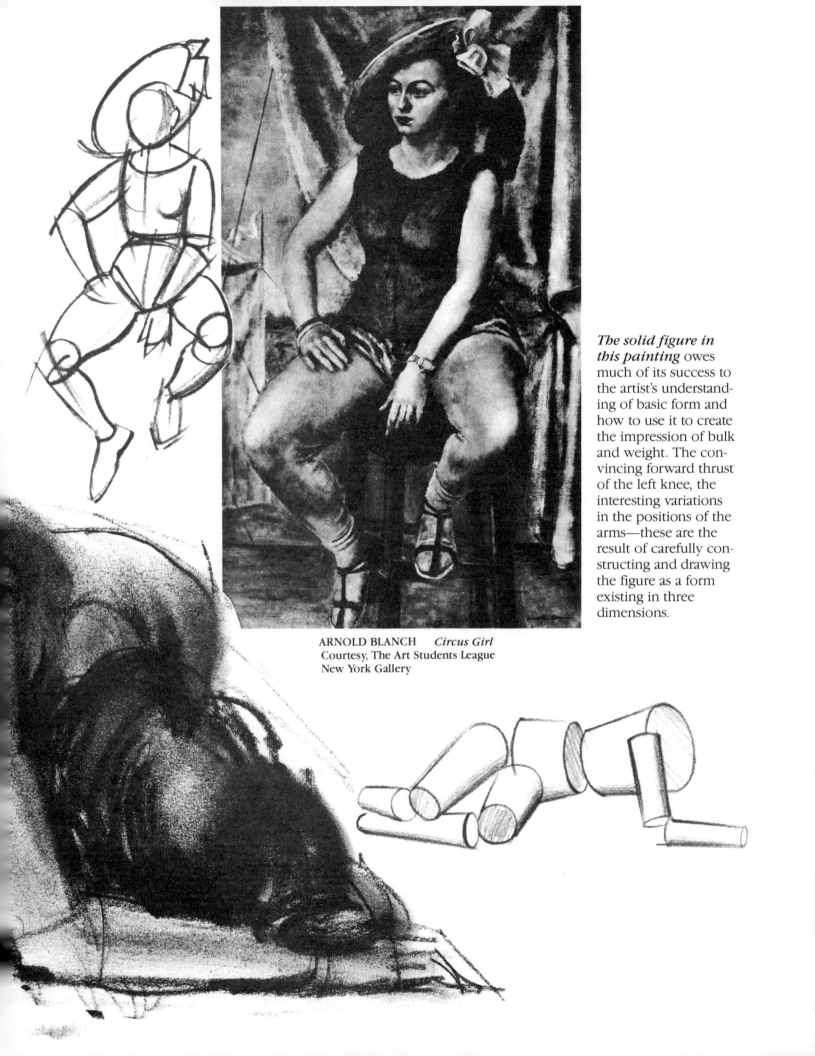

The solid figure in this painting owes much of its success to the artist's understanding of basic form and how to use it to create the impression of bulk and weight. The convincing forward thrust of the left knee, the interesting variations in the positions of the arms—these are the result of carefully constructing and drawing the figure as a form existing in three dimensions.

ARNOLD BLANCH *Circus Girl*
Courtesy, The Art Students League
New York Gallery

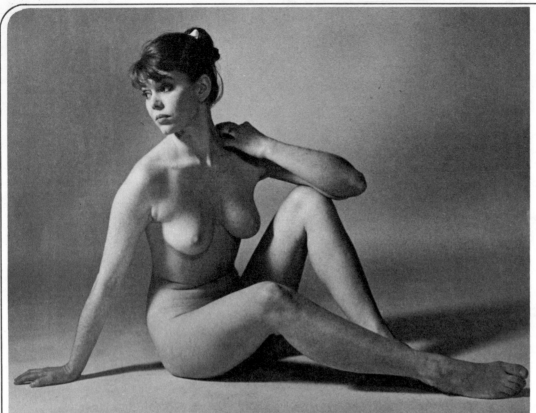

Practice Project
the basic form figure

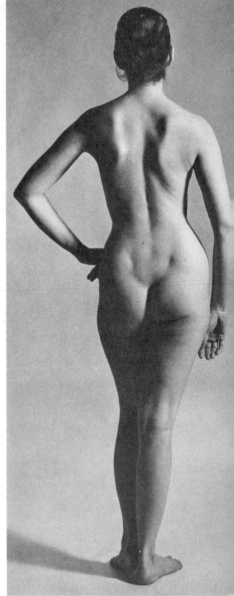

Carefully study each of these figures before you start to draw. Notice how the cylinder-like body forms move in and out of space—sometimes pointing toward you and sometimes pointing away. Now, following the step-by-step method shown on page 24, make basic form figures of these models. Draw them on the facing page (or other sheets of paper), sketching lightly at first and gradually firming up the forms. You may wish to place tracing paper over your first steps, using the method shown on page 80.

The self-correcting overlay, page 83, shows how a Famous Artists School instructor drew these figures. Remove that tissue and place it over your drawings for comparison.

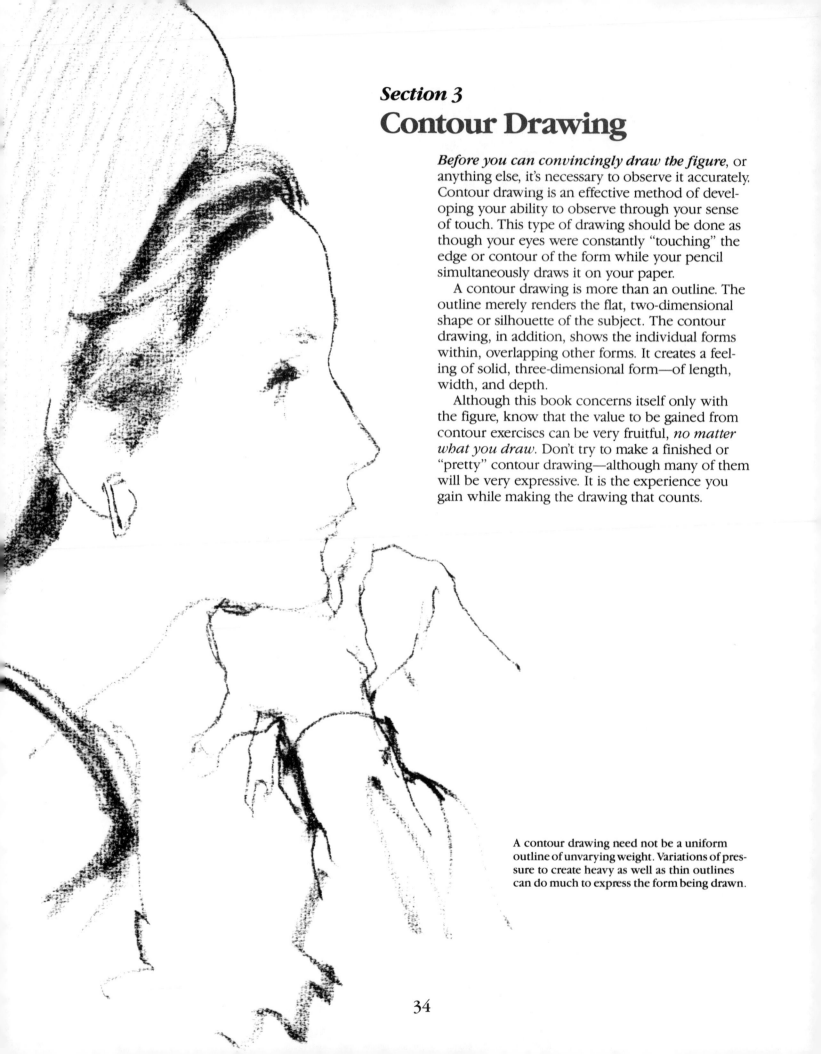

Section 3
Contour Drawing

Before you can convincingly draw the figure, or anything else, it's necessary to observe it accurately. Contour drawing is an effective method of developing your ability to observe through your sense of touch. This type of drawing should be done as though your eyes were constantly "touching" the edge or contour of the form while your pencil simultaneously draws it on your paper.

A contour drawing is more than an outline. The outline merely renders the flat, two-dimensional shape or silhouette of the subject. The contour drawing, in addition, shows the individual forms within, overlapping other forms. It creates a feeling of solid, three-dimensional form—of length, width, and depth.

Although this book concerns itself only with the figure, know that the value to be gained from contour exercises can be very fruitful, *no matter what you draw*. Don't try to make a finished or "pretty" contour drawing—although many of them will be very expressive. It is the experience you gain while making the drawing that counts.

A contour drawing need not be a uniform outline of unvarying weight. Variations of pressure to create heavy as well as thin outlines can do much to express the form being drawn.

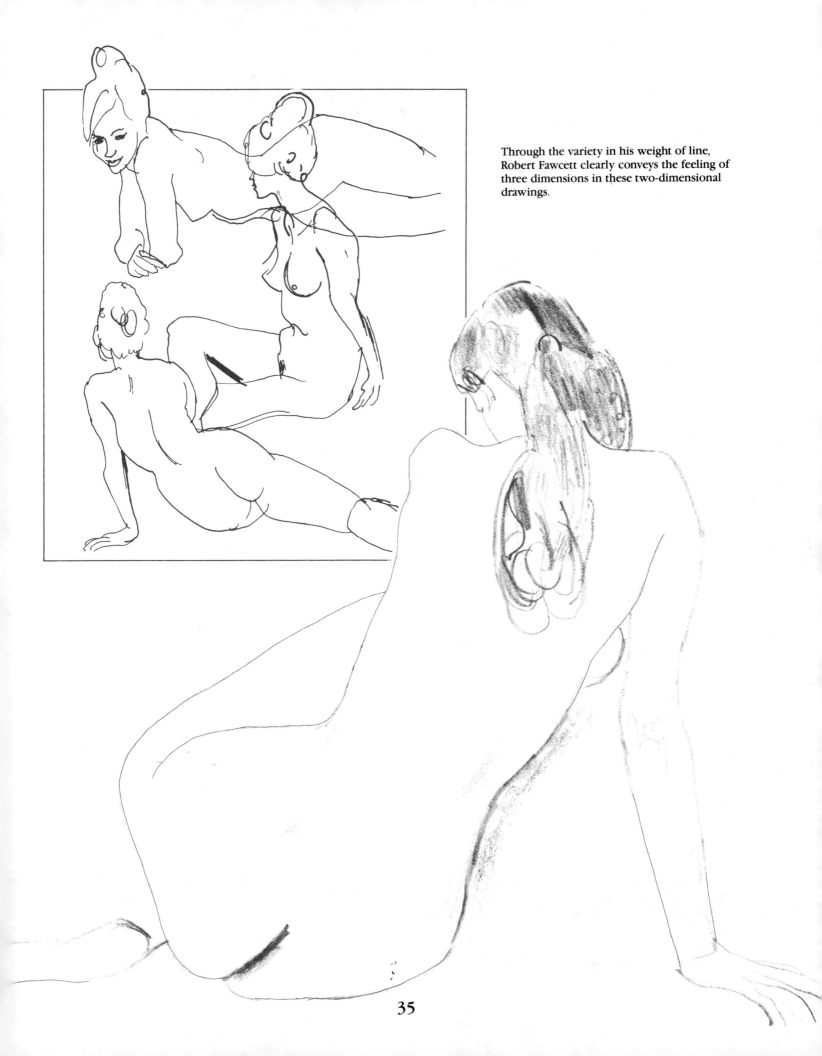

Through the variety in his weight of line, Robert Fawcett clearly conveys the feeling of three dimensions in these two-dimensional drawings.

Making a Contour Drawing
...an exercise

To make a contour drawing, place yourself close enough to the model to see all the variations in the forms and shape of the figure. Fix your eyes on any point along the model's edge or contour. The tip of your pencil rests on the paper, ready to draw, but imagine that it is touching the point where your eyes are focused. Move your eyes slowly along the contour, at the same time slowly moving your pencil to draw a corresponding contour on the paper. Don't look at the paper! Don't worry about the rest of the drawing! Keep concentrating on the idea that your pencil tip is actually in contact with the edge that your eyes are following. Follow the edge of each form of the figure until you come to where it ends or changes direction. At times it will leave the edge of the figure and turn inside, there to

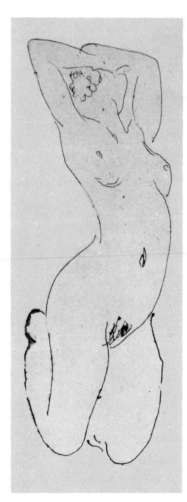

Henri Matisse *Nude Kneeling*
Collection, The Museum
of Modern Art

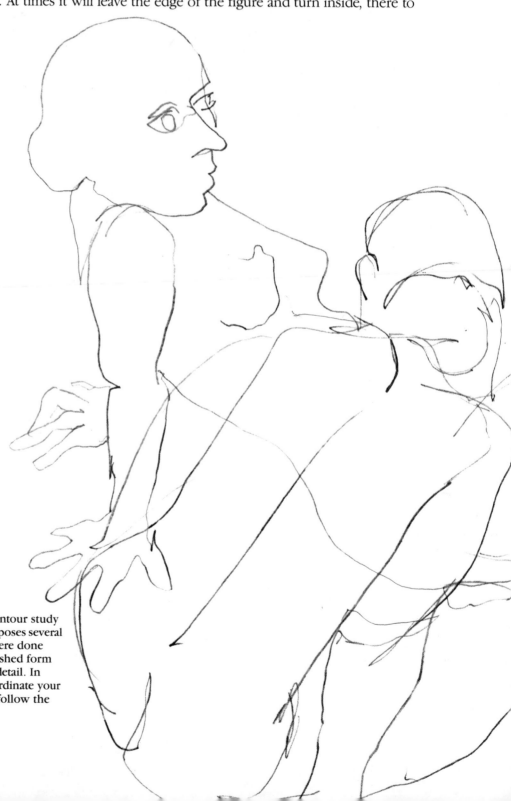

The student drawing at the right is a contour study made from a nude model who changed poses several times during the session. The figures were done with a flowing but firm line that established form and mass without attempting to show detail. In doing a contour drawing you must coordinate your eyes and the tip of your pencil as they follow the edge of the form in front of you.

meet another form or appear to end. When this happens, glance down at the paper to establish a new starting point; then look back at the model and continue to draw the contour as it proceeds in the new direction.

Make sure that you don't let your gaze move faster than your pencil. Your attention should be concentrated on the point where your eyes are focused, while you are drawing that same point. You need not be concerned about the accuracy of the overall drawing. It's practically impossible to make an accurate drawing if you are following the method we have described. Avoid a vague or sketchy line. Work slowly and deliberately, taking as much time as you need—the visual experience is what you're after.

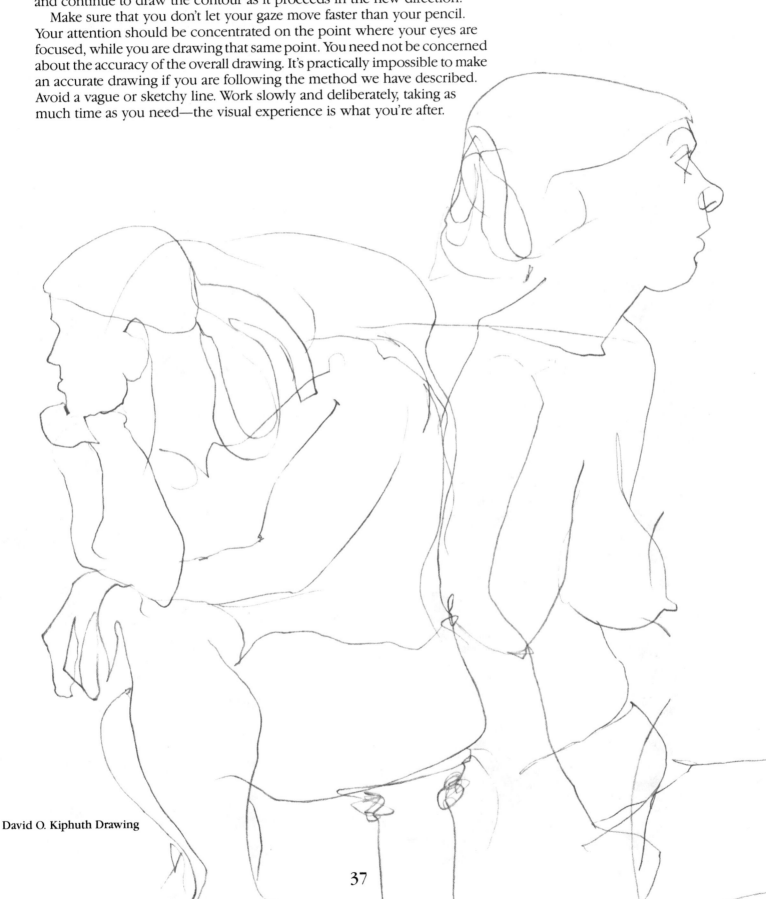

David O. Kiphuth Drawing

37

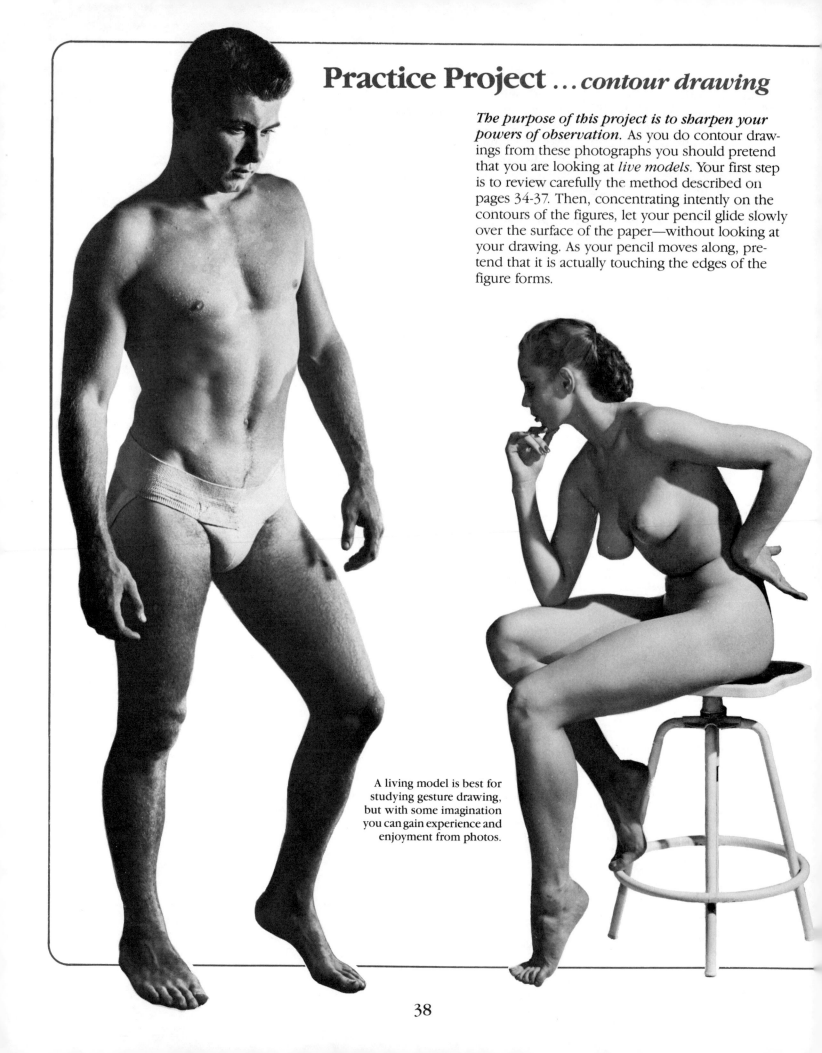

Practice Project ... *contour drawing*

The purpose of this project is to sharpen your powers of observation. As you do contour drawings from these photographs you should pretend that you are looking at *live models*. Your first step is to review carefully the method described on pages 34-37. Then, concentrating intently on the contours of the figures, let your pencil glide slowly over the surface of the paper—without looking at your drawing. As your pencil moves along, pretend that it is actually touching the edges of the figure forms.

A living model is best for studying gesture drawing, but with some imagination you can gain experience and enjoyment from photos.

38

When you've completed your drawings, remove the self-correcting overlay, page 84, and place it over your drawings to see helpful suggestions from a Famous Artists School instructor.

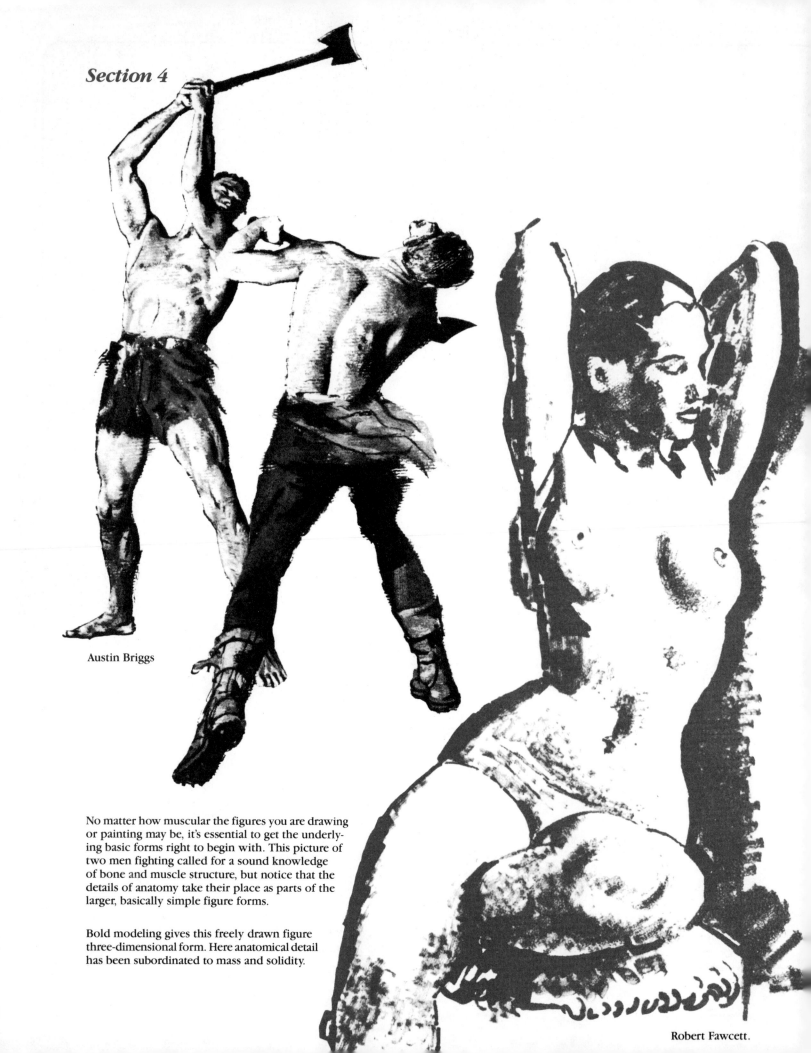

Section 4

Austin Briggs

No matter how muscular the figures you are drawing or painting may be, it's essential to get the underlying basic forms right to begin with. This picture of two men fighting called for a sound knowledge of bone and muscle structure, but notice that the details of anatomy take their place as parts of the larger, basically simple figure forms.

Bold modeling gives this freely drawn figure three-dimensional form. Here anatomical detail has been subordinated to mass and solidity.

Robert Fawcett.

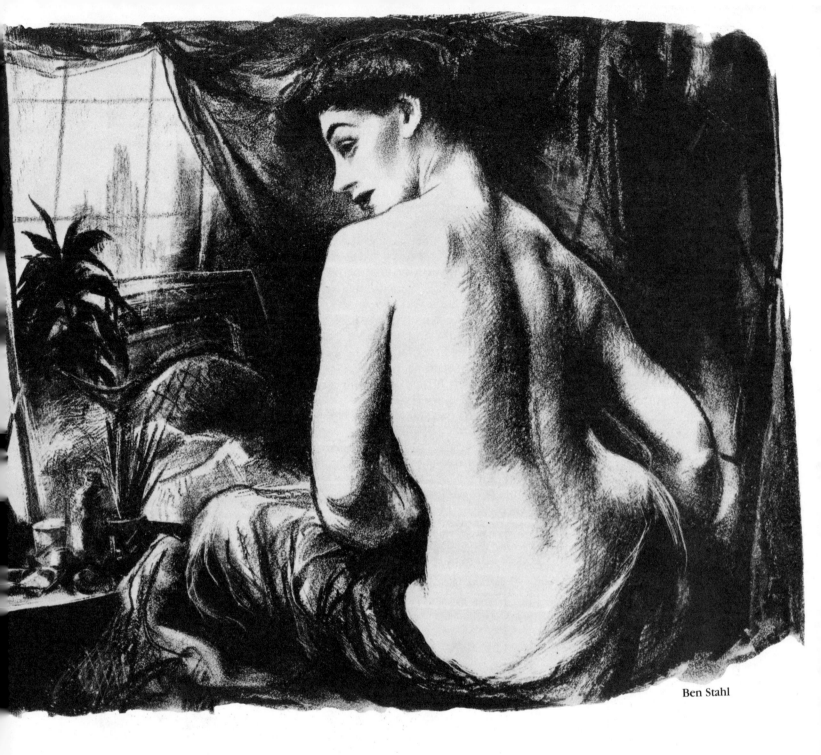

Ben Stahl

The Figure as a Solid Form

The human figure is a solid form. It has bulk and weight, as a rock has bulk and weight. The figure has depth and thickness as well as height and width. It exists in three dimensions.

So far we have looked at the figure in several different ways, each planned to build on the next. From the gesture for the overall attitude of the figure, to the basic figure as a means of establishing proportions, on to contour drawings to see the shapes, we now come to the consideration of form and bulk.

Whether the artist constructs the human body out of clay or stone or draws it on a flat surface, he or she must always think of it as a three-dimensional object. Paper lacks the third dimension of depth, but we can still create the feeling of depth in the figure we draw on it.

In each of these drawings the artist has achieved a feeling of bulk and weight. Each is characterized by the strong "plastic" or structural quality of the form. Study these drawings carefully. Copying them will also be helpful.

41

Form and Bulk

Until you learn to have a feeling for form, your drawings, despite their attributes, will always fall short of truly portraying the figure because they won't suggest bulk, weight or volume.

To understand form, you must first *sense it*—sense its three-dimensional shape, and then sense the *weight of that shape.*

You cannot fully represent those qualities in line. Line is really a slender bent graphic wire, and you're seeking to render *bulk and mass.* Hence you must do it with density and compactness. Only the use of tone will give you that.

Understand that we're not talking about superficial light and shadow *on the surface,* but rather the shape and weight of limbs, the torso, the head. This is accomplished by *starting at the core* and describing its form and bulk with light tones for that portion that comes forward and dark tones to make something turn and recede. Imagine that you are rendering it *all around*—not just the surface that faces you.

You will, in effect, be upholstering a gesture and a contour drawing. Imagine, too, that you are starting with a wire armature at the core and padding the figure in the appropriate places at the same time as you are broadly rendering its three-dimensional shape in space.

Practice this with the flat of your chalk and *find your way out to the edge* with no interest in local details.

Don't make the mistake of thinking that bulk applies only to hefty, chunky figures. *All bodies have bulk*—and your drawings should indicate how, where, and how much, even on slim people.

Ignore the artificial light and shade on your model, determining only how the mass of the body exists. *Feel that mass* in your mind's eye and then interpret it by indicating, with light tones, those planes and shapes that come towards you, and with bold darker tones, those portions that recede. As these tonal areas build up they will form masses of varied tone and *a solid human* will begin to occupy its place in space.

Forget details. Strive only for rounded and blocked volumes for now.

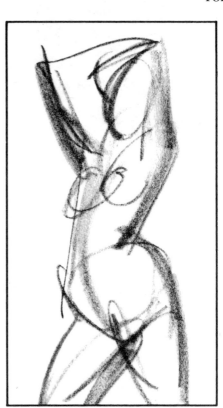 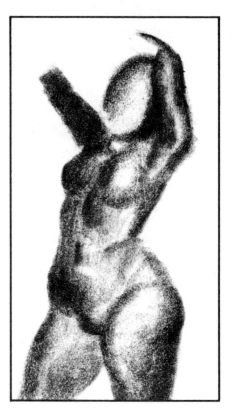 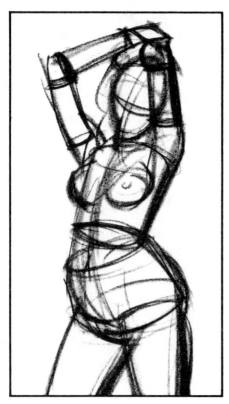

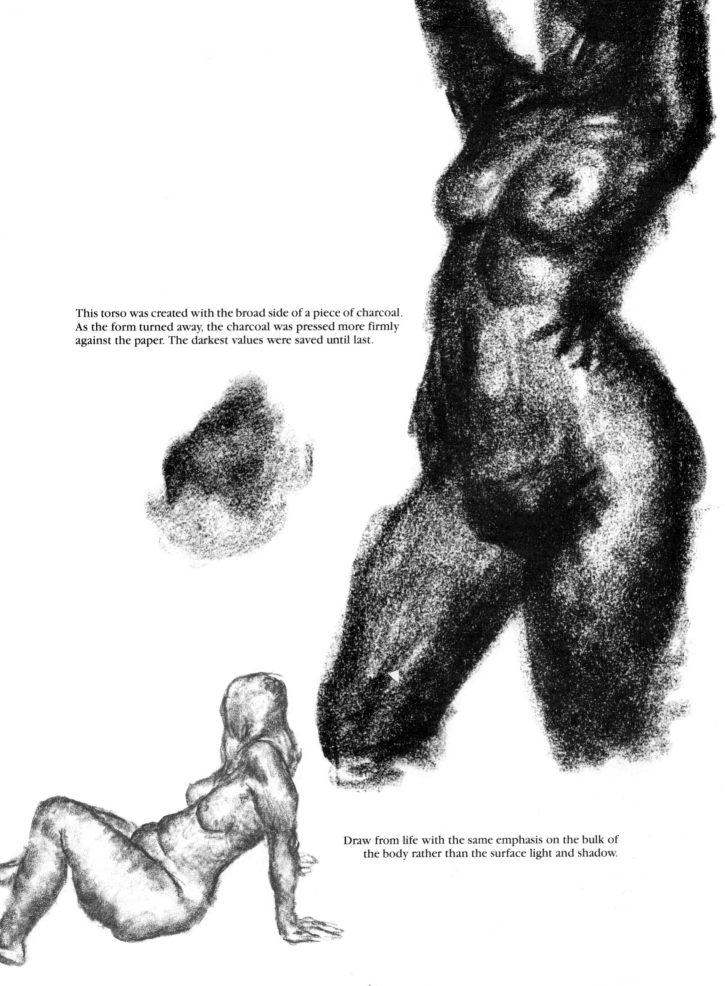

This torso was created with the broad side of a piece of charcoal. As the form turned away, the charcoal was pressed more firmly against the paper. The darkest values were saved until last.

Draw from life with the same emphasis on the bulk of the body rather than the surface light and shadow.

43

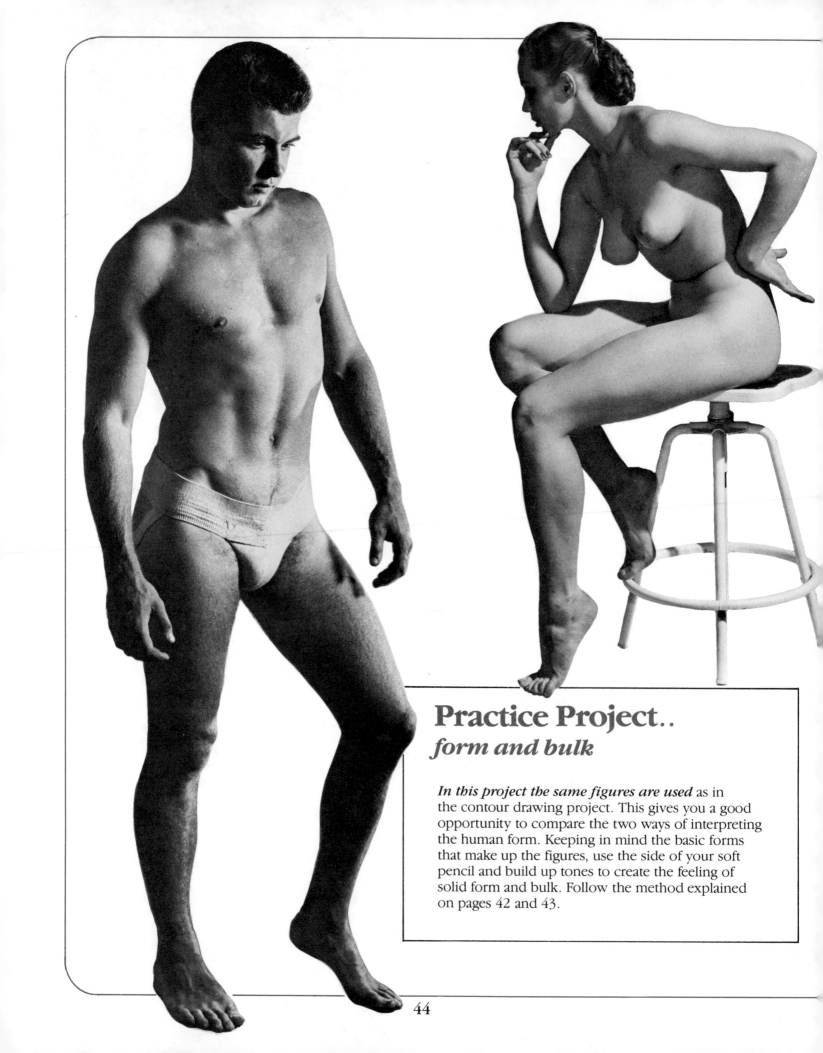

Practice Project..
form and bulk

In this project the same figures are used as in
the contour drawing project. This gives you a good
opportunity to compare the two ways of interpreting
the human form. Keeping in mind the basic forms
that make up the figures, use the side of your soft
pencil and build up tones to create the feeling of
solid form and bulk. Follow the method explained
on pages 42 and 43.

When you've completed your drawings remove the transparent Instructor
Overlay, page 85. Lay it over your work for comparison and helpful suggestions.

Section 5
Artistic Anatomy…*relative proportions*

The artist uses the human head as his basic unit of measurement for the entire human figure. The head can be viewed in two ways. The height of the head from chin to top of skull is "the ruler" by which all *vertical measurements* are made. When the artist speaks of an "eight-head figure," he means that the figure is *eight vertical heads high.* Use *the width of the head* in making horizontal measurements. The shoulders, for instance, are *three head widths* across.

 If you look at the people around you, you will realize how much they differ in proportion. One has a head which is large for his body, another has a head which seems smaller than normal. The majority of people, however, are reasonably similar in proportions and shape at any given age. This is why clothing manufacturers can design "ready-made" suits and dresses.

 Artists have always sought to discover *the ideal, the perfect* figure. The Greek sculptors established a "canon" for the human figure. Later, Leonardo and Dürer set up their own. Rubens' hefty, voluptuous beauties were once much admired, when women were considered beautiful only if they had monumental propor-

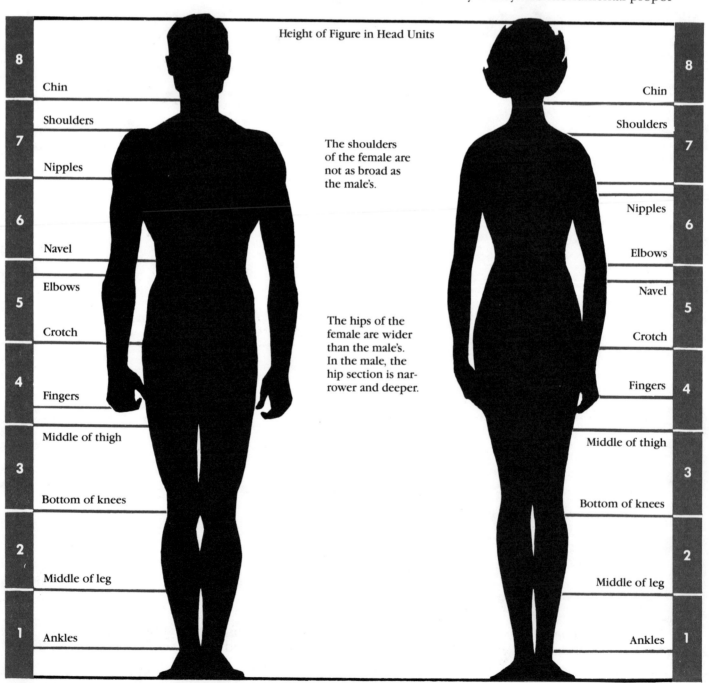

Height of Figure in Head Units

The shoulders of the female are not as broad as the male's.

The hips of the female are wider than the male's. In the male, the hip section is narrower and deeper.

Male	Female
8	8
Chin	Chin
Shoulders	Shoulders
7	7
Nipples	
	Nipples
6	6
Navel	Elbows
Elbows	Navel
5	5
Crotch	Crotch
4	4
Fingers	Fingers
Middle of thigh	Middle of thigh
3	3
Bottom of knees	Bottom of knees
2	2
Middle of leg	Middle of leg
1	1
Ankles	Ankles

tions. Today popular taste has swung in the opposite direction: thin is in.

Hence, the eight-head figure has become the standard for the virile male in modern illustrations.

Often, however, in commercial work or in cartooning, you will need to portray people who are neither average nor ideal. You can do this easily by retaining *the same width measurements* used to draw the eight-head figure, but reducing the height to five or six heads, or increasing the height to nine or ten heads, as in the case of a modern basketball player.

Rely on your eyes for correct proportion. The head as a unit of measure is convenient and helpful when you are first learning figure proportions. You must realize, however, that you should not make figure drawings with dividers or a ruler. You make them with your pencil and your eyes! Therefore, the only way to gauge proportions is by sight. If it looks right it is right. Study these charts and fix in your mind the size of one part of the body compared with another. Remember that skillful drawing is skillful seeing, transferred to paper.

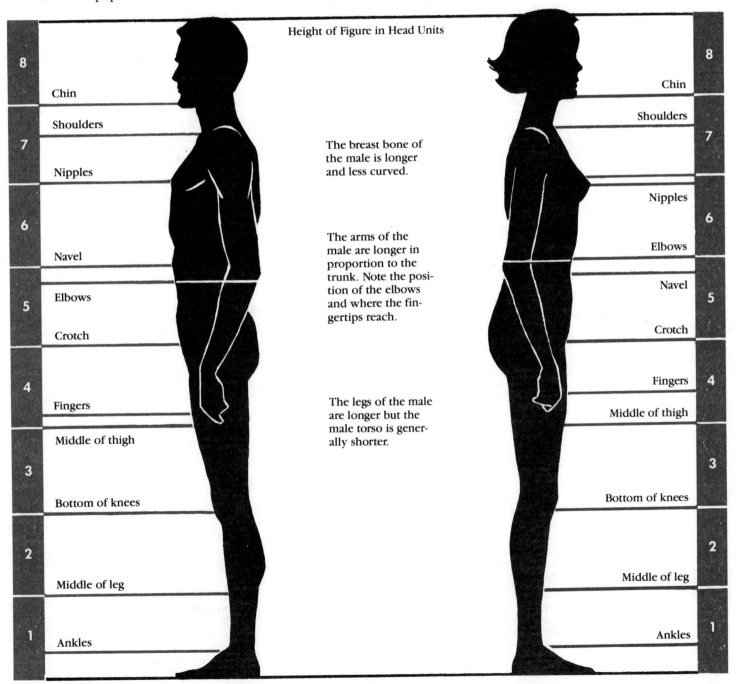

Height of Figure in Head Units

The breast bone of the male is longer and less curved.

The arms of the male are longer in proportion to the trunk. Note the position of the elbows and where the fingertips reach.

The legs of the male are longer but the male torso is generally shorter.

Left figure (male) labels, top to bottom: 8, Chin, Shoulders, 7, Nipples, 6, Navel, 5, Elbows, Crotch, 4, Fingers, Middle of thigh, 3, Bottom of knees, 2, Middle of leg, 1, Ankles

Right figure (female) labels, top to bottom: 8, Chin, Shoulders, 7, Nipples, 6, Elbows, Navel, 5, Crotch, Fingers, 4, Middle of thigh, 3, Bottom of knees, 2, Middle of leg, Ankles, 1

Artistic Anatomy... *the skeleton*

These drawings show the differences between the male and female skeletons and explain why the surface forms are different in the sexes.

The bones of the female are smaller and smoother, and more heavily covered with fatty tissue. They are less apparent on the surface tha the larger, coarser bones of the male skeleton.

The female has a smaller, narrower rib cage with a shorter, more curved breastbone. The female's shoulders are not so broad as the male's and her collar bones are straighter and smaller.

The female has a longer torso and shorter legs than the male. Her pelvis is broader and shallower, and this makes the hips much wider. Note the greater distance from the top of the pelvis to the rib cage. The pelvis in the male is about the same width as the rib cage while *the female pelvis is wider* than the rib cage.

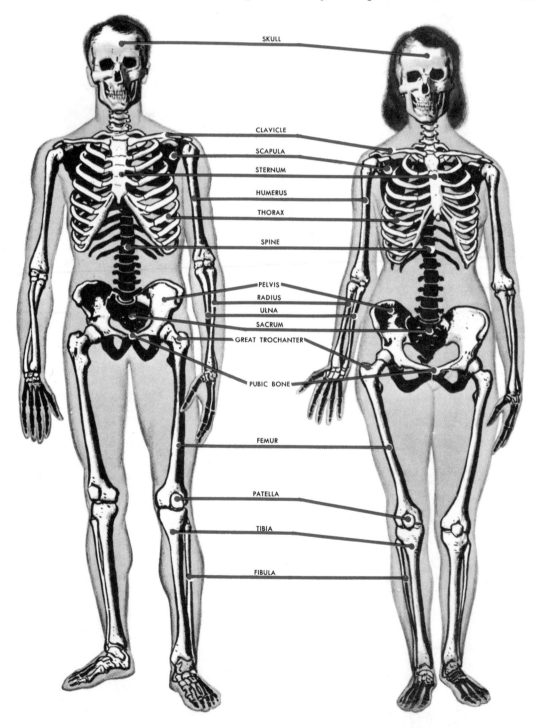

SKULL

CLAVICLE

SCAPULA

STERNUM

HUMERUS

THORAX

SPINE

PELVIS

RADIUS

ULNA

SACRUM

GREAT TROCHANTER

PUBIC BONE

FEMUR

PATELLA

TIBIA

FIBULA

...the muscles of the body

These front and rear view diagrams of the male figure show the main muscles that influence the surface appearance of the body. The female has exactly the same muscles, but they are smaller and are covered by a thicker layer of fat.

Learn the size, position and action of these muscle groups. Knowledge of the muscles and their action will make it easier for you to interpret what you see in a real model or a photo.

There is no need to memorize the names of all these muscles. It is much more important to know what they are, where they begin and end, and what they do.

Keep in mind that these are diagrams, not drawings of the appearance of the figure. Use them only for study. When you draw the figure, you should show no more anatomy than appears on the surface. This may be a large amount if you are drawing an athlete.

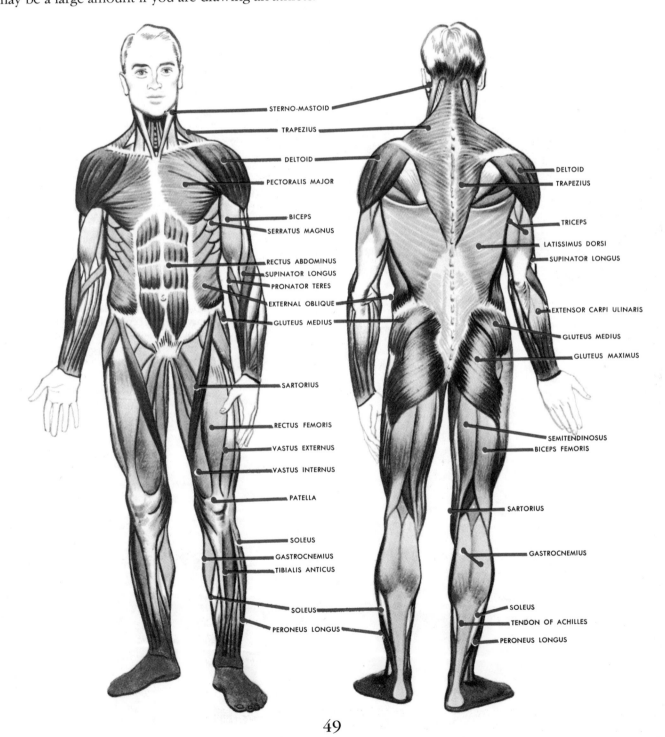

STERNO-MASTOID
TRAPEZIUS
DELTOID
PECTORALIS MAJOR
BICEPS
SERRATUS MAGNUS
RECTUS ABDOMINUS
SUPINATOR LONGUS
PRONATOR TERES
EXTERNAL OBLIQUE
GLUTEUS MEDIUS
SARTORIUS
RECTUS FEMORIS
VASTUS EXTERNUS
VASTUS INTERNUS
PATELLA
SOLEUS
GASTROCNEMIUS
TIBIALIS ANTICUS
SOLEUS
PERONEUS LONGUS

DELTOID
TRAPEZIUS
TRICEPS
LATISSIMUS DORSI
SUPINATOR LONGUS
EXTENSOR CARPI ULINARIS
GLUTEUS MEDIUS
GLUTEUS MAXIMUS
SEMITENDINOSUS
BICEPS FEMORIS
SARTORIUS
GASTROCNEMIUS
SOLEUS
TENDON OF ACHILLES
PERONEUS LONGUS

49

The Head

Each of us spends more time looking into the faces of other humans than at any other single sight. The attention of most people is invariably focused on reading expressions and emotions rather than on how a person's face or "head" (as artists refer to it) is constructed.

The head is basically egg-shaped, with the small end at the chin. To this add the protuberance of the nose. The eyes set in under a usually overhanging brow. With the positioning of ears and mouth, the transformation from egg to head is well under way.

Once the solid form of the head has been sketched in, the correct location of the features can be established as indicated below.

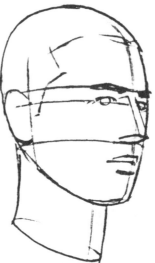
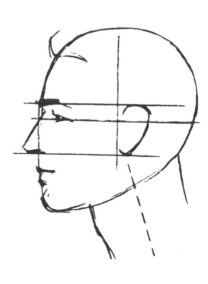

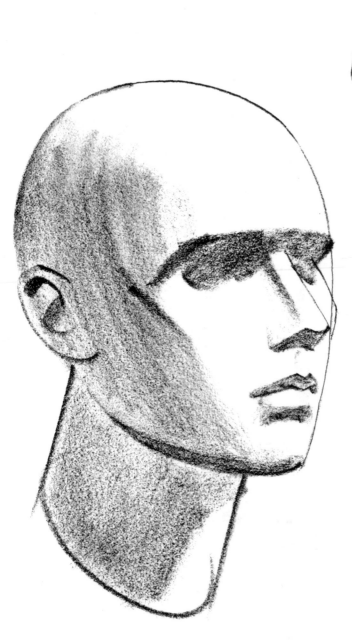

How to place the features

The eyes are on an imaginary horizontal line about halfway between the chin and the top of the head. The bottom of the nose is about halfway between eyebrows and chin. Place the mouth about one-third of the way between the nose and chin.

The side view shows the eye is placed *back* from the front of the face. Locate the ear just behind a vertical line halfway between the front and back of the skull.

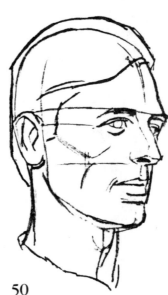
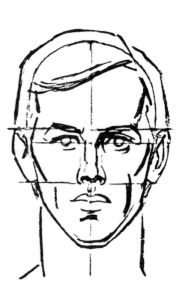

50

The Torso

The torso or trunk is the body's greatest mass. It is also many other things: the central core from which the neck and head and all four limbs emerge.

And because people's torsos take on so many different degrees of development, size, shape and character, they greatly determine the "look" of a person—posture, gait, age, fitness, etc.

Think for a moment of any person of either sex or any age that you know well on sight. Chances are that you can conjure up their appearance by your recollection of their torsos alone. That's how important the torso's cosmetic effect will be on your drawings.

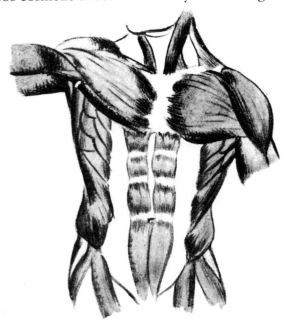

This diagram allows you to view the muscle structure that underlies the general shape of the torso and pelvic area.

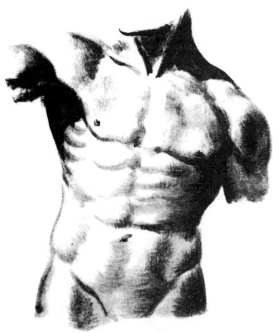

This drawing shows how the underlying structure, shown at the left, influences the surface appearance.

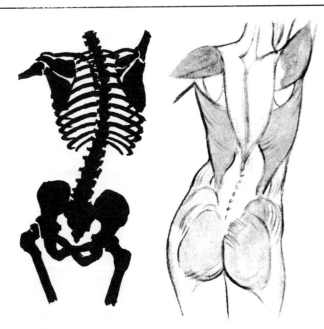

In back views, the shoulder and hip width varies between male and female and then varies within each sex as well.

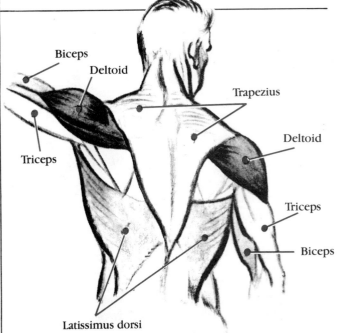

Here is the amazing structure of torso in action. Keep this construction in mind when you draw every pose. This will keep you from doing superficial surface drawings with no underlying foundation.

51

The Arm

The human arm is a remarkable machine that can lift, push, throw, punch, rotate and bend in a myriad of directions and angles. It begins at the shoulder and terminates in the hand —the universal symbol of toil, might, brotherhood, skill and artistic touch.

The simplified drawings on these two pages were chosen to show you the basic architecture of the arm: from the bone structure to the muscle arrangement to the skin-covered final product; which you can easily examine by taking off your shirt and feeling and looking.

Bear in mind that the muscular construction is the same in both the male and female figure— except that muscles are much less obvious in women.

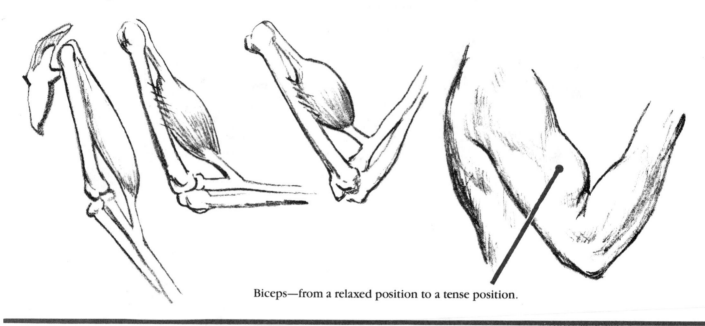

Biceps—from a relaxed position to a tense position.

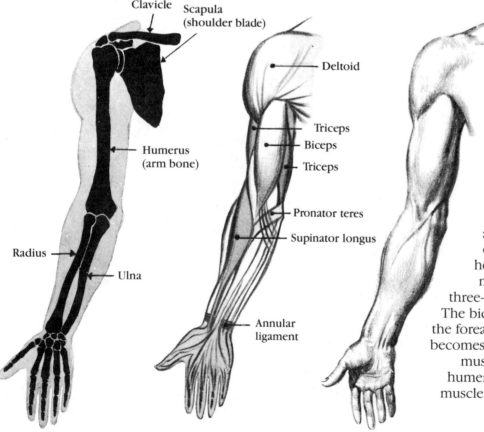

The mass of the shoulder, or deltoid, comes down as a wedge and sinks into the outer arm, halfway down. The muscle on the front of the arm is a two-headed one called the biceps; the muscle on the back of the arm is three-headed and is called the triceps. The biceps bends the elbow and flexes the forearm. When doing this the biceps becomes shorter and thicker. The triceps muscle runs the entire length of the humerus on the back of the arm. This muscle acts in opposition to the biceps and straightens the arm.

52

The muscles of the forearm may be divided into two groups, flexors and extensors. They operate upon the wrist and hand through tendons, which pass under the wrist band or annular ligament. The two most important muscles in the forearm are the supinator, the long outside muscle extending from the wrist to one-third up the humerus (upper arm bone); and the pronator teres, a short, round muscle which passes obliquely downward across the forearm from the inner condyle of the humerus to halfway down the outer border of the radius. These two muscles pull the radius with a rotary motion over the ulna and back again, carrying the thumb side of the hand toward or away from the body.

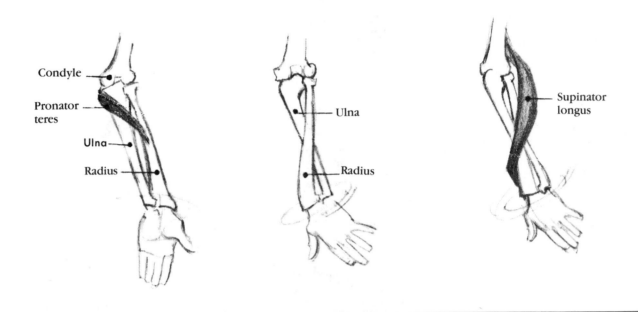

The hand does not join the arm directly, but joins the wrist, which in turn attaches to the arm and is seen as a wedge-shaped mass in any action. This wrist joint is universal in its scope, permitting it to move in a rotary, up-and-down or side-to-side movement. Its range of action is almost unlimited.

From the armpit, the arm gradually gets smaller in width to the elbow. This is more noticeable in profile than in the front view. The fleshy mass of the forearm near the elbow widens in excess of the breadth of the upper arm and in turn gets narrower again at the wrist.

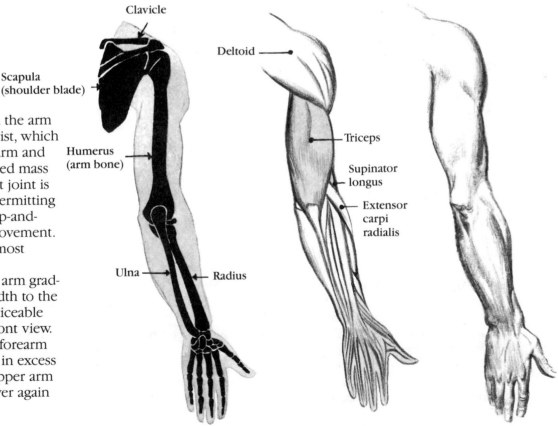

53

The hand and wrist—
their construction and action...

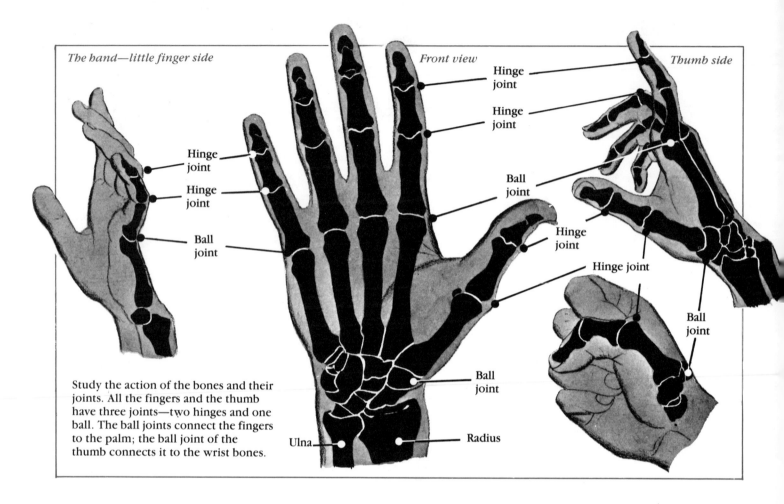

The hand—little finger side

Front view

Thumb side

Hinge joint

Hinge joint

Hinge joint

Hinge joint

Ball joint

Hinge joint

Hinge joint

Hinge joint

Hinge joint

Ball joint

Ball joint

Ball joint

Ball joint

Study the action of the bones and their joints. All the fingers and the thumb have three joints—two hinges and one ball. The ball joints connect the fingers to the palm; the ball joint of the thumb connects it to the wrist bones.

Ulna

Radius

Hands should always be drawn large enough. Many students tend to make them too small in relation to the rest of the figure.

To understand the action of the hand, study the movement of the wrist. As it transmits the action of the arm to the hand, the wrist enters into the large movements of the arm, giving it grace and power. The wrist can be called a universal joint, for it is capable of side-to-side and up-and-down movement as well as rotary movement. Study carefully the diagrams and try these movements out on your own hand and wrist.

It is helpful to think of the hand as being composed of three masses—the palm, the thumb part, and the mass of the fingers.

The palm has the form of a shallow bowl that is roughly rectangular in shape and well cushioned around the edges. A line across the wrist marks the lower limit of the palm. The upper limit is also definitely marked by lines across the base of the fingers. Measure the length of the palm and you will find it about an inch longer than the finger above that part of the palm. You will notice, too, that the palm is longer than the back of the hand. Except when the hand is clenched in a fist, the back of the hand is quite flat.

Most of the modeling in the palm of the hand is caused by a system of fleshy cushions and pads with which it is thickly upholstered. These cushions cover the bony framework of the palm. The same is true of the fingers on the palm side.

The thumb is the most active and powerful finger on the hand. It is set into the palm by the highly mobile "ball of the thumb," which gives it a great range of movement independent of the rest of the hand. The thumb moves in any direction.

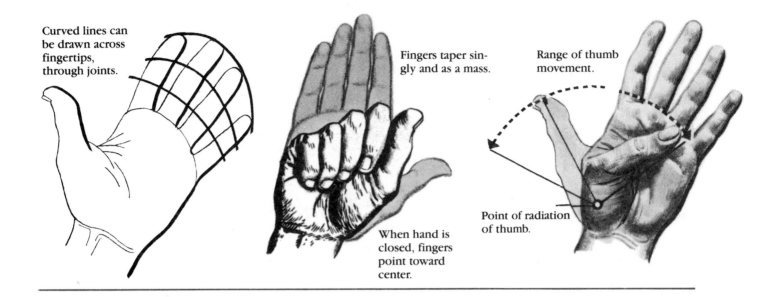

Curved lines can be drawn across fingertips, through joints.

Fingers taper singly and as a mass.

When hand is closed, fingers point toward center.

Range of thumb movement.

Point of radiation of thumb.

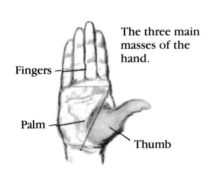

The three main masses of the hand.

Fingers

Palm

Thumb

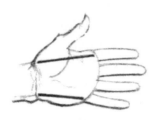

Palm is larger on thumb side.

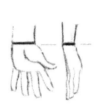

Wrist is twice as wide as thick.

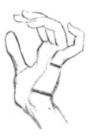

Palm is thick near wrist, thinner near fingers.

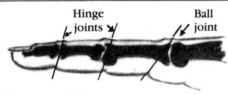

Hinge joints

Ball joint

Placement of skin folds in relation to joints.

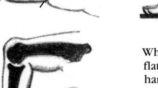

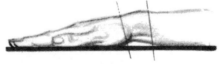

When the hand and arm are placed flat on table, wrist slants down to hand, it does not touch table.

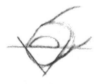

Fingertips are slightly triangular in shape.

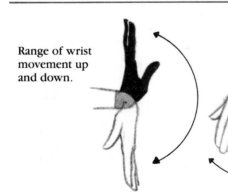

Range of wrist movement up and down.

Range of wrist movement from side to side.

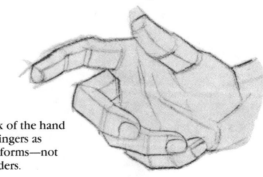

Think of the hand and fingers as cube forms—not cylinders.

The upper part of the leg encases the body's largest bone: the femur. And it's attached as is the arm, by a ball and socket joint—which, because of its life-long heavy tasks, is larger and is set deeper.

The Leg and Foot

When we are in a normal standing position with the full weight of the body on the legs, our knee is *behind* a line dropped from the *front of the thigh.* The leg does not stand in a strictly *vertical position.* It slants back from the top of the thigh to the ankle.

From the side, we see a full curve at the front of the thigh while the back is fairly straight. In the lower leg the opposite is true; here the shin is flatter, the calf at the back is full and rounded. Whether we are looking at the leg from the front or back, it shows an *inward slant* from top to bottom.

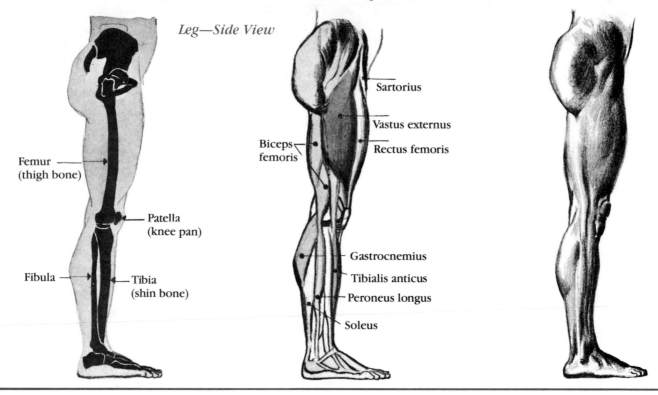

Leg—Side View

Sartorius

Vastus externus

Biceps femoris

Rectus femoris

Femur (thigh bone)

Patella (knee pan)

Gastrocnemius

Fibula

Tibialis anticus

Tibia (shin bone)

Peroneus longus

Soleus

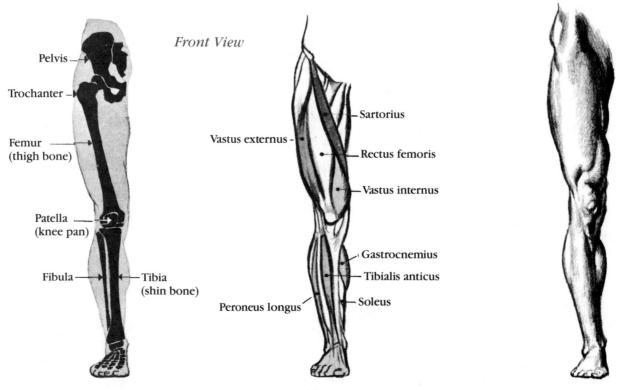

Front View

Pelvis

Trochanter

Sartorius

Vastus externus

Rectus femoris

Femur (thigh bone)

Vastus internus

Patella (knee pan)

Gastrocnemius

Fibula

Tibialis anticus

Tibia (shin bone)

Peroneus longus

Soleus

56

The thigh is well rounded, but as it tapers to the knee the planes become angular. Above each side of the knee they are quite flat. When the knee bends, we see its broad bony surface clearly. From the back, the hips and buttocks look square as they overhang the thighs. The backs of the calves are curved, rounding as they enter the flat surfaces on either side of the shinbone (tibia). The shaft of the leg just above the ankle is quite round but changes into more angular surfaces as it joins the foot. The Achilles tendon creates the broad flat plane at the back.

The outside line showing the contour of the thigh is the most varied. In profile, the fullness of the front of the thigh must be stressed; the most usual and more extreme actions in the thigh come from the *front group of muscles* and not from those on the back of the thigh. Below the knee, the reverse holds true.

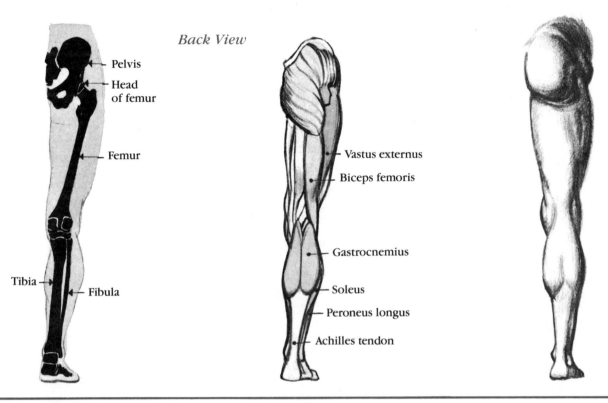

Back View

Pelvis
Head of femur
Femur
Tibia
Fibula

Vastus externus
Biceps femoris
Gastrocnemius
Soleus
Peroneus longus
Achilles tendon

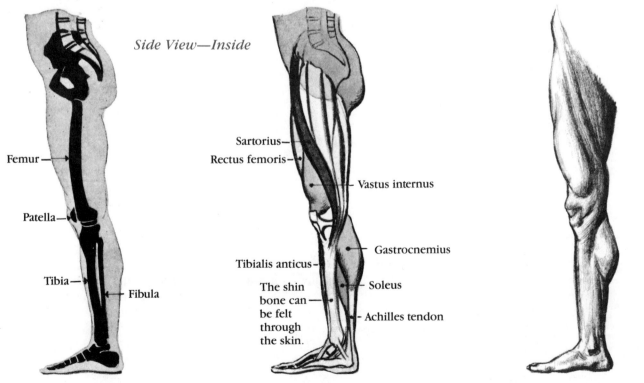

Side View—Inside

Femur
Patella
Tibia
Fibula

Sartorius
Rectus femoris
Vastus internus
Tibialis anticus
The shin bone can be felt through the skin.
Gastrocnemius
Soleus
Achilles tendon

57

Practice Project... *the skeleton*

Skull

Clavicle

Scapula

Sternum

Humerus

Thorax

Spine

Pelvis
Radius
Ulna
Sacrum
Great trochanter

Pubic bone

Femur

Patella

Tibia

Fibula

The outline drawings on this page are the same as the figures on page 48. To familiarize yourself with the bone structure, carefully fill in the skeletons, referring to page 48 from time to time. When you have finished, rule lines from the printed names to the bones in your drawing. Then remove the transparent Instructor Overlay, page 86, and place it over your work for comparison and help.

Practice Project... *the muscles*

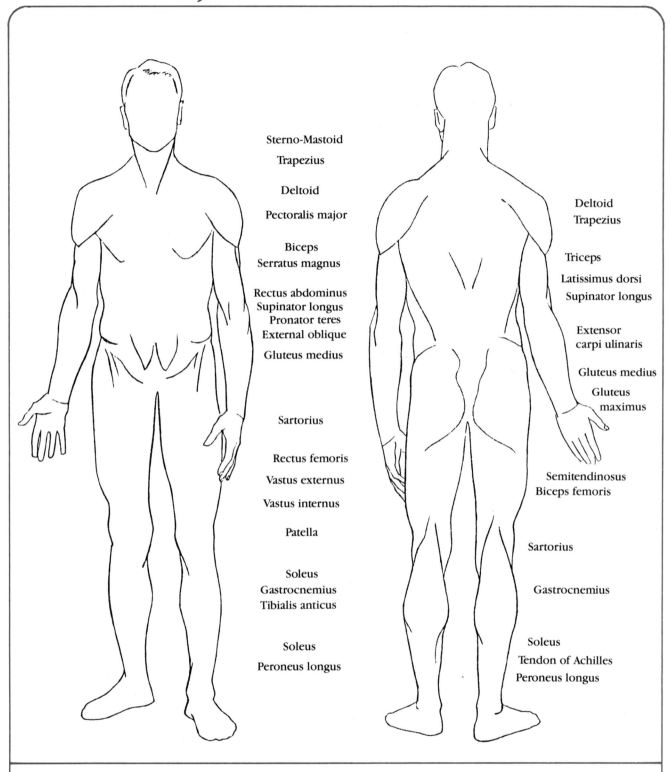

Sterno-Mastoid

Trapezius

Deltoid

Pectoralis major

Biceps
Serratus magnus

Rectus abdominus
Supinator longus
Pronator teres
External oblique

Gluteus medius

Sartorius

Rectus femoris

Vastus externus

Vastus internus

Patella

Soleus
Gastrocnemius
Tibialis anticus

Soleus

Peroneus longus

Deltoid
Trapezius

Triceps

Latissimus dorsi
Supinator longus

Extensor
carpi ulinaris

Gluteus medius

Gluteus
maximus

Semitendinosus
Biceps femoris

Sartorius

Gastrocnemius

Soleus
Tendon of Achilles
Peroneus longus

The outline drawings on this page are the same as the figures on page 49. To familiarize yourself with the muscles, carefully draw them within the outlines, referring to page 49 from time to time. When you have finished, rule lines from the printed names to the muscles in your drawings. Then remove the transparent Instructor Overlay, page 87, and place it over your work for comparison and help.

59

Section 6
Humanizing the Basic Form Figure

When you have advanced to the point where you are able to view any pose and automatically see and sketch it in its *basic forms*—cylinders, cubes and spheres—you are on the brink of doing meaningful drawings with authority and conviction.

You have now only to join these forms together, and flesh them out with detail and personality, to create living, creditable human figures capable of any kind of gesture and activity, from calmly passive to wildly active.

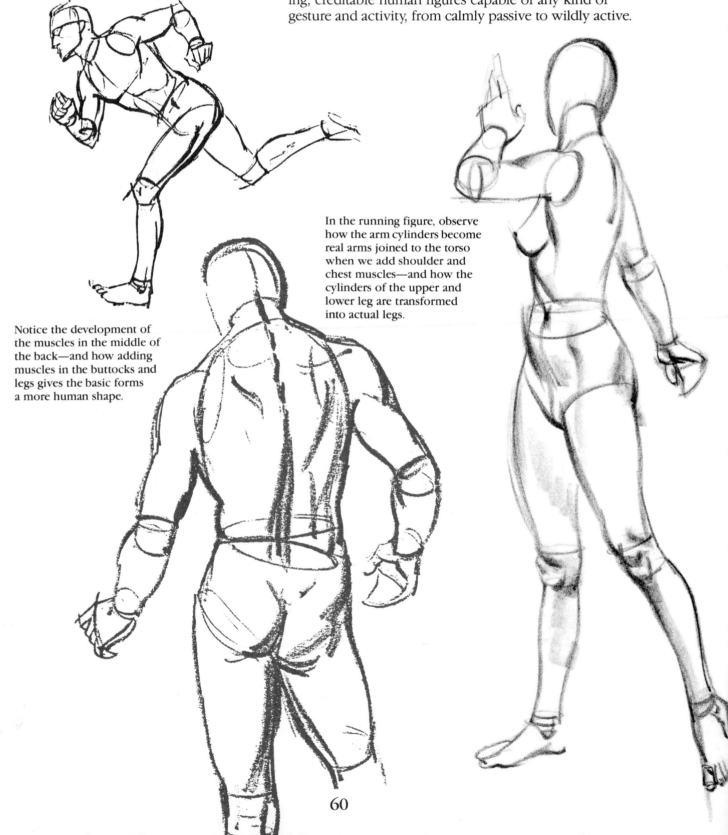

In the running figure, observe how the arm cylinders become real arms joined to the torso when we add shoulder and chest muscles—and how the cylinders of the upper and lower leg are transformed into actual legs.

Notice the development of the muscles in the middle of the back—and how adding muscles in the buttocks and legs gives the basic forms a more human shape.

60

As you develop your drawing from the gesture to the humanized figure, remember to visualize the parts of the form figure in terms of the cylinder, cube, and sphere. Use ordinary drinking glasses to help you see how the ellipses look in the simple cylinders of the upper and lower torso, the upper and lower arms, and the upper and lower legs. Think of the head as a simple sphere. Remember the law of balance and equilibrium. Draw all these forms through to the other side.

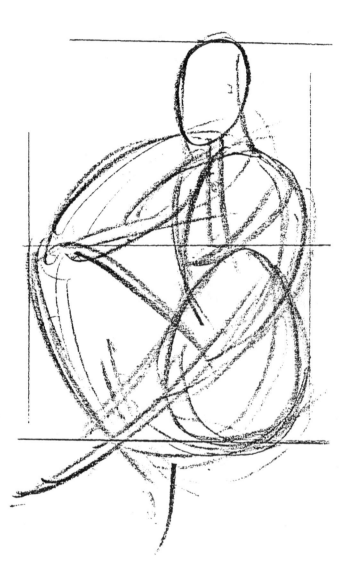

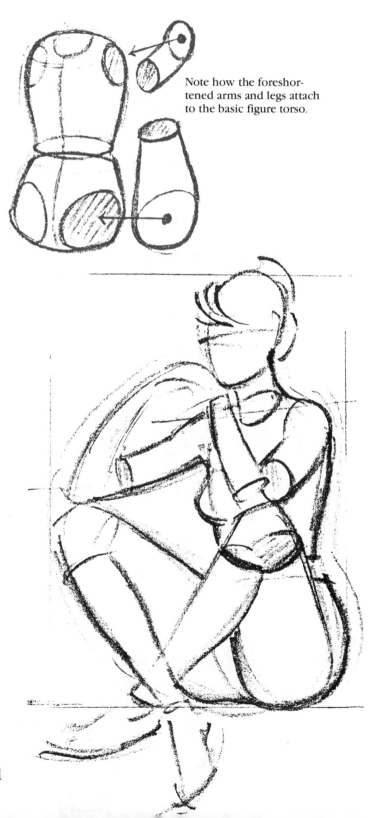

Note how the foreshortened arms and legs attach to the basic figure torso.

These three drawings progress from a rhythmic gesture sketch, to a basic form interpretation, to a diagram showing how the arm and leg cylinders join to the ball and socket joints of the shoulder and the hip.

The logic and simplicity of this method of learning is surprisingly simple compared to trying to draw the figure obscured by a maze of muscles, shadows, cosmetic detail and other superficialities that get in the way of seeing and understanding.

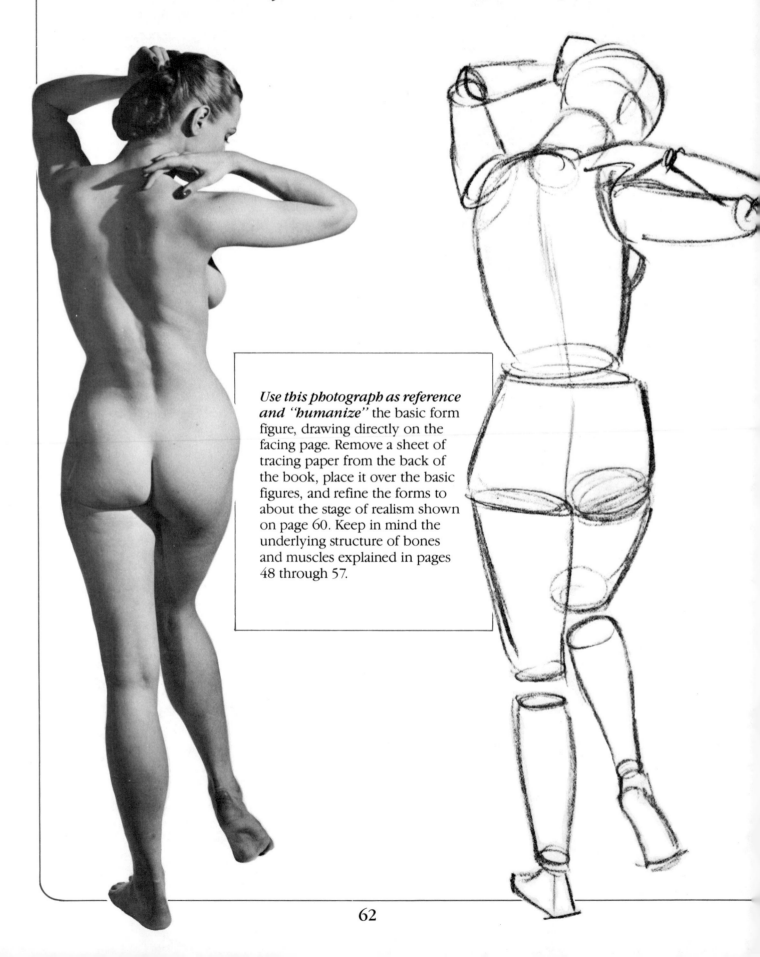

Practice Project...*humanizing basic forms*

Use this photograph as reference and "humanize" the basic form figure, drawing directly on the facing page. Remove a sheet of tracing paper from the back of the book, place it over the basic figures, and refine the forms to about the stage of realism shown on page 60. Keep in mind the underlying structure of bones and muscles explained in pages 48 through 57.

When you finish, place the Instructor Overlay, page 88, over your work for comparison and help.

Section 7

Lighting
the Figure

It's important when artificially lighting your model to emphasize the form and not to create stark melodramatic black shadows and odd angles that distort true form.

Learn to use your lights to create a positive light and shadow pattern that is both pleasing and plausible.

Keep the light coming from a single source to avoid confusing cross shadows.

Acquire a couple of inexpensive clamp-on reflector-type metal lamps. These are adjustable in all directions.

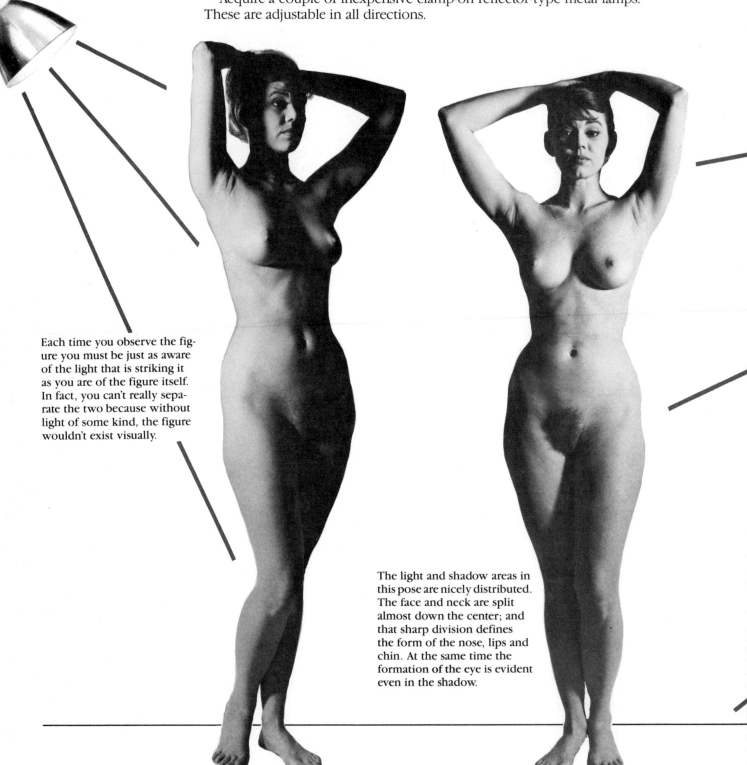

Each time you observe the figure you must be just as aware of the light that is striking it as you are of the figure itself. In fact, you can't really separate the two because without light of some kind, the figure wouldn't exist visually.

The light and shadow areas in this pose are nicely distributed. The face and neck are split almost down the center; and that sharp division defines the form of the nose, lips and chin. At the same time the formation of the eye is evident even in the shadow.

The light comes from the right on both of these poses. Notice how well the form reads in both the light and the shadow areas. Every part of the body is better defined because of the soft shadows that bring forth rises and depressions, curves and flattened planes.

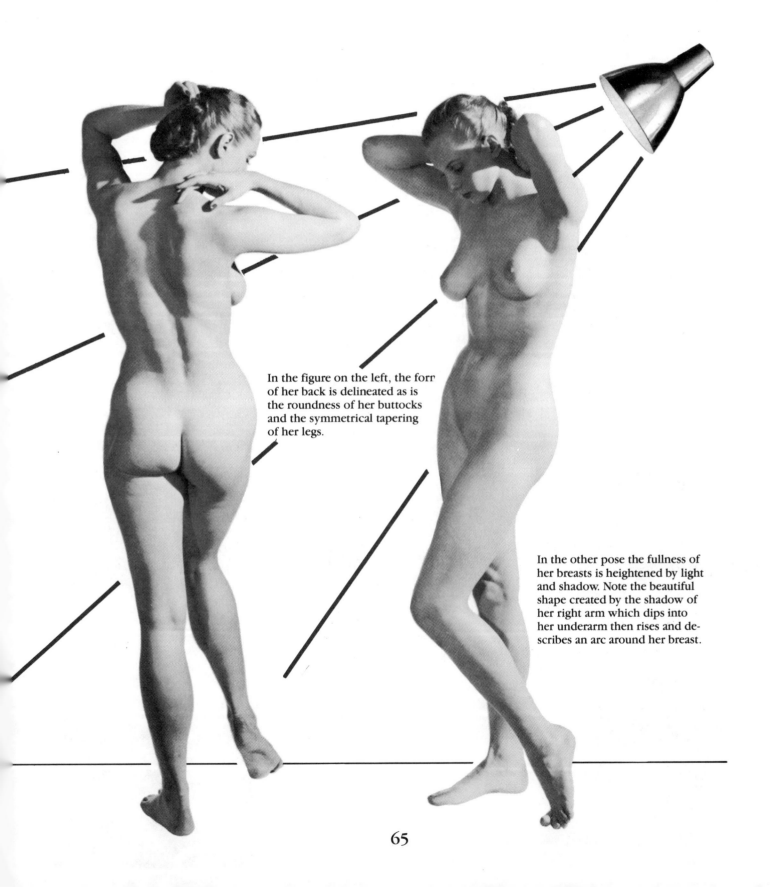

In the figure on the left, the form of her back is delineated as is the roundness of her buttocks and the symmetrical tapering of her legs.

In the other pose the fullness of her breasts is heightened by light and shadow. Note the beautiful shape created by the shadow of her right arm which dips into her underarm then rises and describes an arc around her breast.

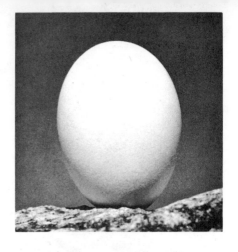

Light and shade on the head...

Regardless of the kind of lighting, you should always be aware of the solid form of the head. This holds true even when you want to emphasize pattern or outline in your drawing. These pictures of the egg and the head demonstrate four basic types of lighting—front, three-quarter front, side, and rear. Every one of these photos shows a basic point you should remember when you draw the head: keep the light and shade simple. You see simplicity of lighting when you look at a head which is lighted from a single source; for example, by a lamp alongside a chair or the direct rays of the late afternoon sun. With such single light sources you can easily see two main tones—the tone of the lightstruck area and that of the shadow area. You'll also see some variation of tone within each area. The tones in the shadow will vary because some light will be reflected there by the surroundings. In the light areas the planes turned slightly away from the light source will be a bit darker. The edge of the shadow begins where the planes of the face turn decisively away from the light.

When you draw or paint a head lighted in this simple way, the modeling in the light area should not be so dark as to break up or confuse the overall light tone. The same principle applies to your modeling in the shadow. When students have trouble with their modeling, they often think the medium is causing the difficulty, but actually it may be the incorrect values with which they've broken up either light or shadow areas.

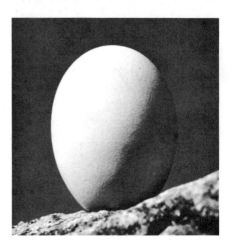

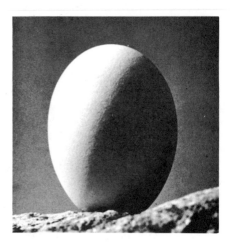

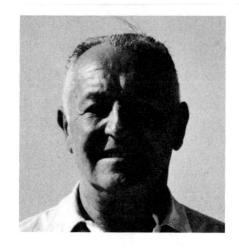

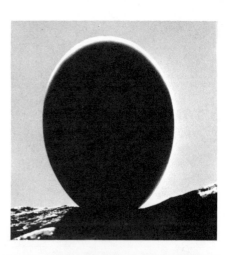

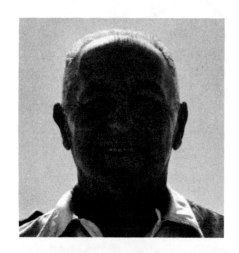

66

Lighting the figure

In lighting the model, adjust the lights to emphasize the form. Try to avoid confusing cross shadows, reflected lights, and cast shadows that conceal form. In the drawing on the right by Robert Fawcett, you will note that a single light source has created a strong shadow pattern.

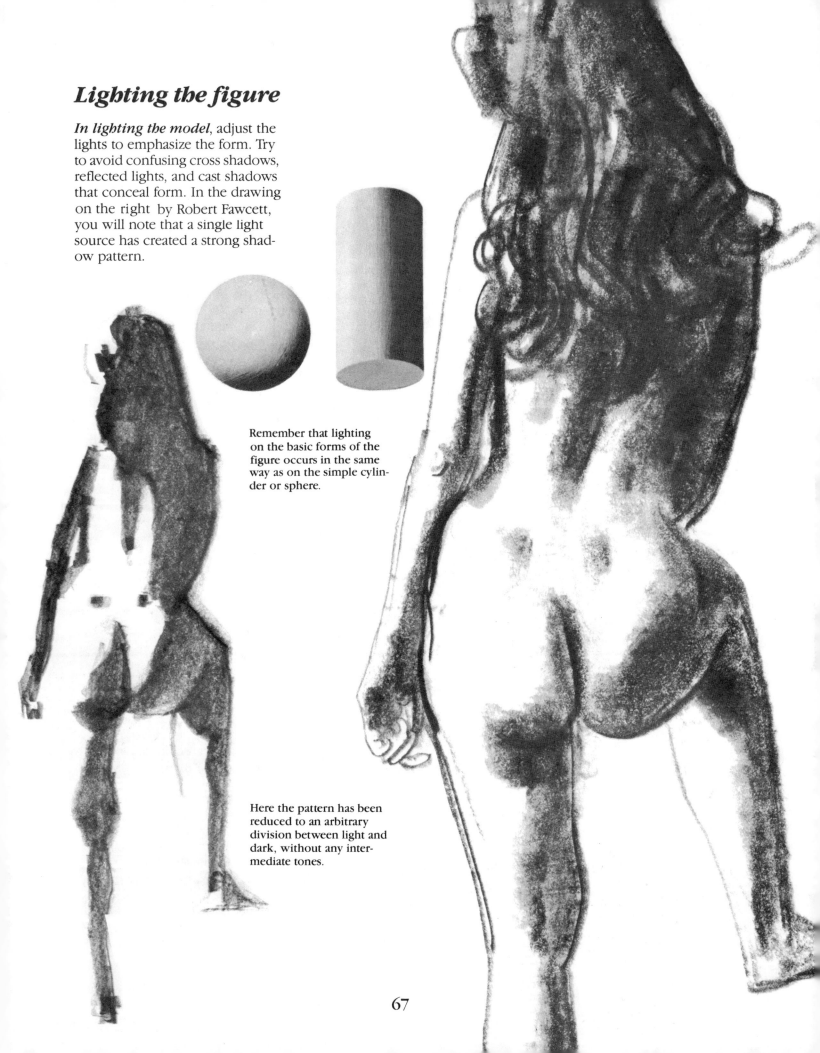

Remember that lighting on the basic forms of the figure occurs in the same way as on the simple cylinder or sphere.

Here the pattern has been reduced to an arbitrary division between light and dark, without any intermediate tones.

67

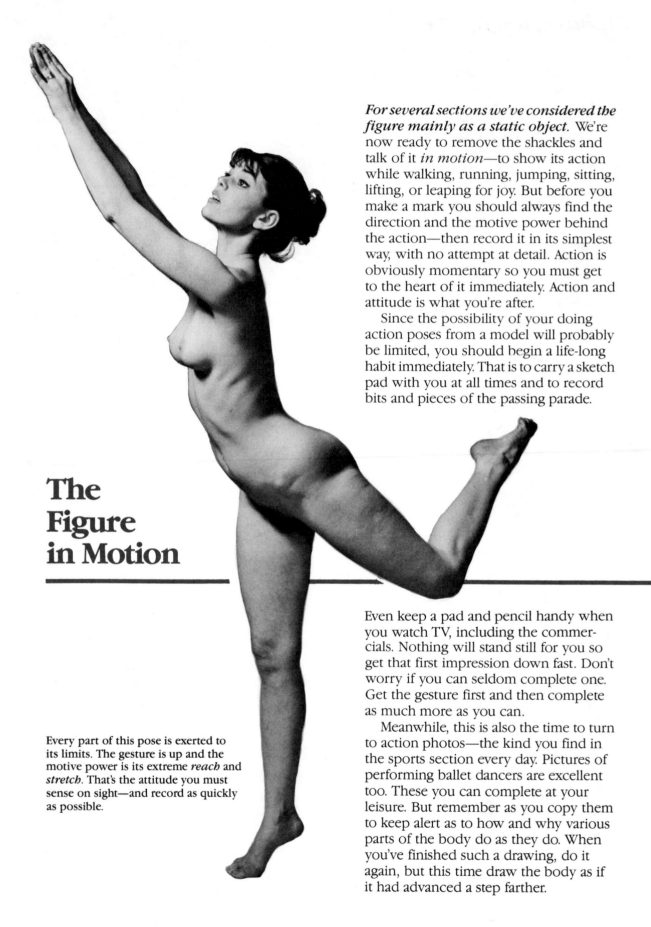

For several sections we've considered the figure mainly as a static object. We're now ready to remove the shackles and talk of it *in motion*—to show its action while walking, running, jumping, sitting, lifting, or leaping for joy. But before you make a mark you should always find the direction and the motive power behind the action—then record it in its simplest way, with no attempt at detail. Action is obviously momentary so you must get to the heart of it immediately. Action and attitude is what you're after.

Since the possibility of your doing action poses from a model will probably be limited, you should begin a life-long habit immediately. That is to carry a sketch pad with you at all times and to record bits and pieces of the passing parade.

The Figure in Motion

Every part of this pose is exerted to its limits. The gesture is up and the motive power is its extreme *reach* and *stretch*. That's the attitude you must sense on sight—and record as quickly as possible.

Even keep a pad and pencil handy when you watch TV, including the commercials. Nothing will stand still for you so get that first impression down fast. Don't worry if you can seldom complete one. Get the gesture first and then complete as much more as you can.

Meanwhile, this is also the time to turn to action photos—the kind you find in the sports section every day. Pictures of performing ballet dancers are excellent too. These you can complete at your leisure. But remember as you copy them to keep alert as to how and why various parts of the body do as they do. When you've finished such a drawing, do it again, but this time draw the body as if it had advanced a step farther.

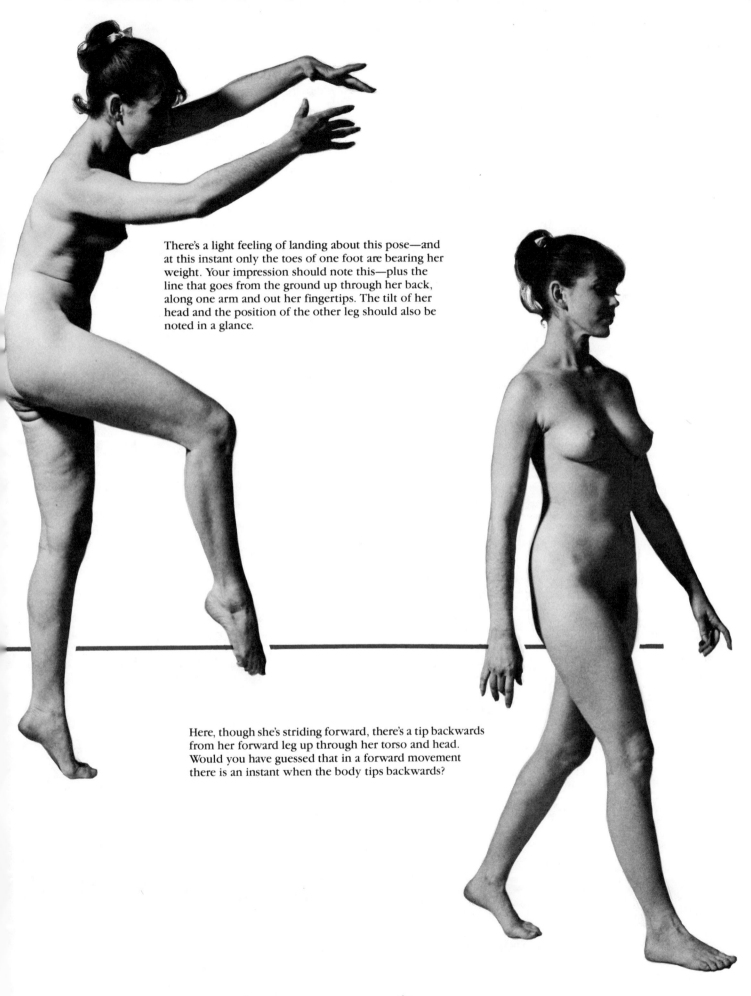

There's a light feeling of landing about this pose—and at this instant only the toes of one foot are bearing her weight. Your impression should note this—plus the line that goes from the ground up through her back, along one arm and out her fingertips. The tilt of her head and the position of the other leg should also be noted in a glance.

Here, though she's striding forward, there's a tip backwards from her forward leg up through her torso and head. Would you have guessed that in a forward movement there is an instant when the body tips backwards?

The Figure in Balance

Balance enables the human being, either standing still or in motion, to keep from falling. This balance results from equalized distribution of weight. When the figure is in motion the stage of balance constantly changes. The artist must be alert to these fleeting instants of balance. Drawings in which the figures are out of balance are always disturbing.

As an aid, start your drawing with a light vertical line as a guide for placing the various parts in the proper positions. This line is just as useful when drawing the figure in attitudes of running, walking, bending, crouching, etc.

In bending to one side, as in the action of lifting a heavy suitcase, or reaching, you will find that you

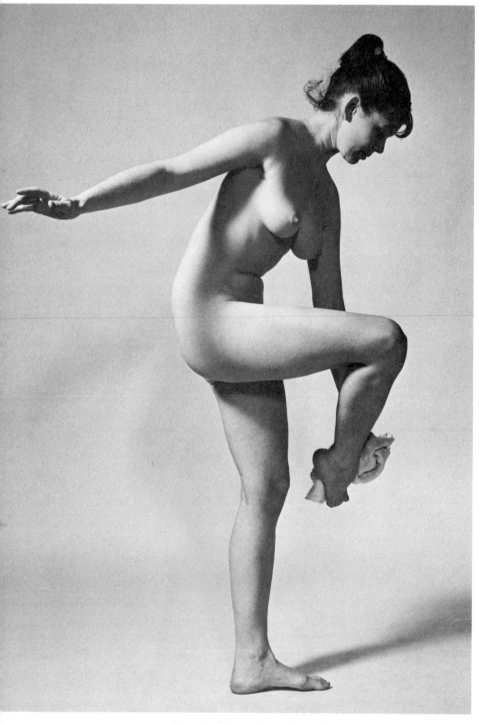

Because of the dual forward weights of the head and lifted leg, this model must extend her arm in the opposite direction to maintain balance.

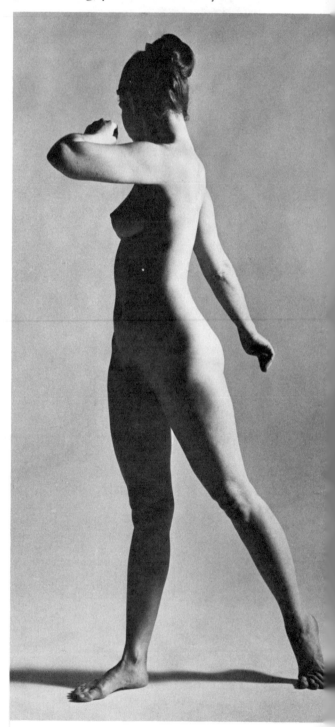

Her balance line runs down her spine to an imaginary line between her right heel and left foot, since they share in bearing her weight. Also, the extreme twist of her torso has set up other forces which are compensated for by the counterweights of her arms.

70

naturally extend the arm on the other side to preserve your balance—and you usually raise the heel of the foot on the other side as well. This shows that you must place a sufficient weight on the opposite side to preserve your balance in every attitude and action. When the body bends, it tends to lengthen on one side as much as it shortens on the other.

The spinal column is the key to balance all through the body. Its flexibility allows it to automatically adjust to changes of positions and shifts of weight, thereby affecting the slant of the shoulders and hips as well as the turning and bending of the torso.

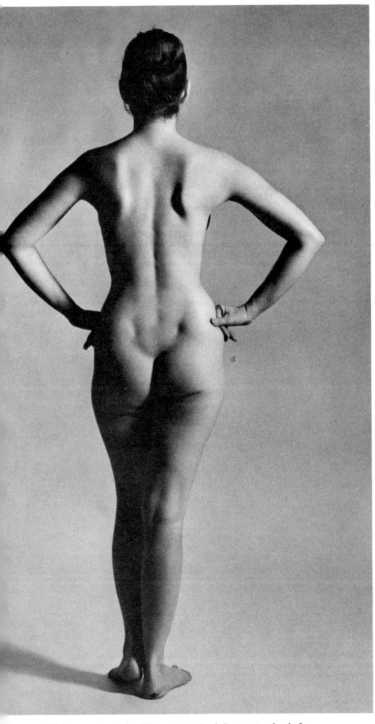

This pose is perfectly symmetrical down to the left leg which is a bit forward.

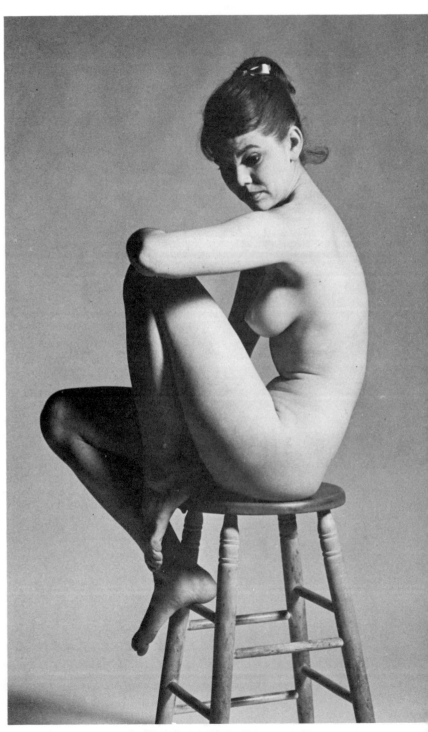

Her weight is off her feet here and rests upon her buttocks. She can adjust any imbalance by pressure on either one of her heels against the stool.

The Figure *Walking*

In walking, the body alternately shifts its weight first to one leg and then the other, with the center of balance over the foot on the ground. The leg is extended slightly in advance of the body—the heel touches the ground first, quickly followed by the toes. With the forward foot resting on the ground, the heel of the other foot is raised, with the knee bending slightly as the leg swings forward past the other. As this leg swings forward, the foot of the other leg bears the whole weight of the body. As the leg swings forward to rest on the ground, it takes its turn at supporting the weight of the body. During this process the body is always passing vertically over the supporting foot.

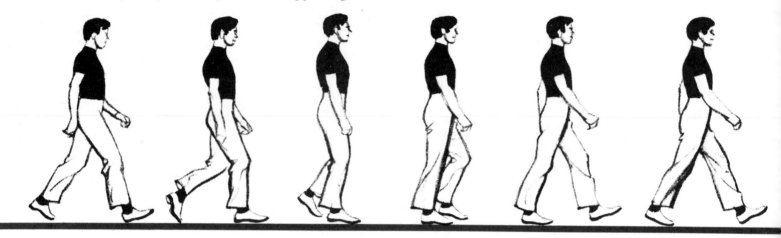

Each time that the foot is raised it thrusts the weight of the body *to the side over the other foot* as well as forward. The unconscious effort to balance the movement of the limbs in walking causes the arms to swing alternately in opposite directions to the legs so that when the right leg *swings forward* the right arm *swings back*—with the reverse action applying to the other two limbs.

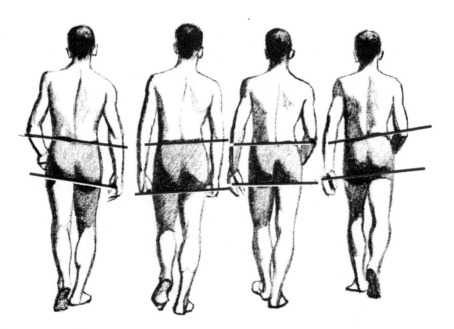

A longer stride, accompanied by a more pronounced alternate swinging of the arms, distinguishes a fast walk from an ordinary normal walk. When you draw either of these actions, remember to show that the knees are bent, to avoid an appearance of stiffness.

This man is walking at a normal pace and performing a complete stride. Draw the same thing yourself so you'll understand the arm and leg positions as a walker proceeds. Note the direction and movement of the hips and buttocks as the weight shifts from one foot to the other in a normal walking stride.

Observe, too, how the forward foot crosses in front of the rear one—and closely misses as they pass each other.

The Figure *Running*

***When running, the body should always be thrown* ahead** of the center of gravity.

The faster the figure runs, the further forward the body is thrust in front of the imaginary line of balance. Unless these fundamental actions are observed and correctly drawn, they will never look convincing.

With the endless number of sports events now on television, you have a steady stream of running models to observe and draw from. Keep a sketch pad handy with your TV schedule.

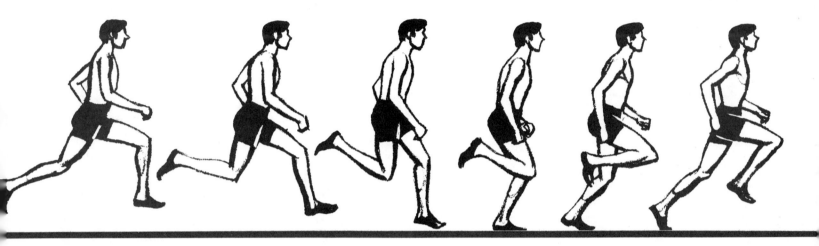

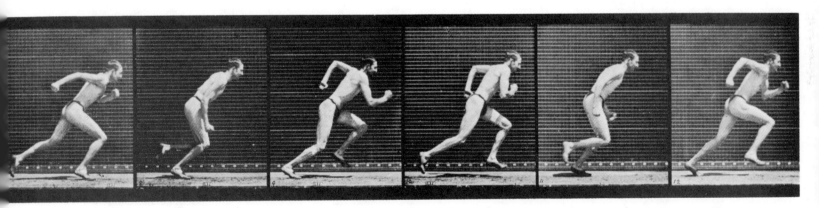

Every phase of an action has its own over-all attitude or flow of movement. In the case of these stopped-action photos, the runner's attitude is one of hustling forward with strength, drive and determination.

Study the flow of movement here—the angle of the body, the position of the arms and legs. It's these large observations you must make, not petty detail which will be meaningless if the broad action is not correct.

Drawing the Standing Female Figure

This is an appropriate point for you to start with the photo of the standing nude and to draw it five different times on successive sheets of tracing paper—each time building on the information gleaned from the preceding one. (This tracing paper method is explained on page 80.)

But before you touch your paper, look the figure over carefully. Study the main lines of action, the direction of the arms, legs and torso and the position of the head.

Now do a spirited *gesture drawing* to know the flow of the pose.

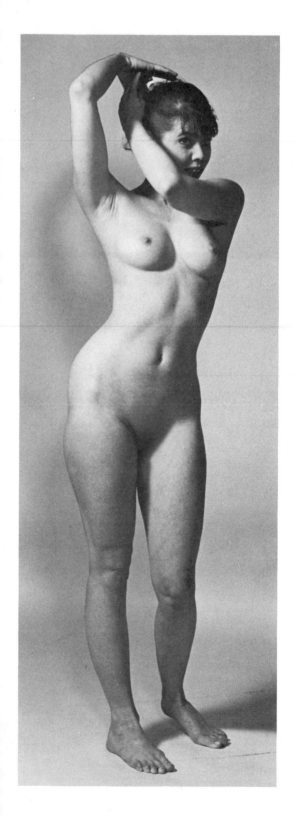

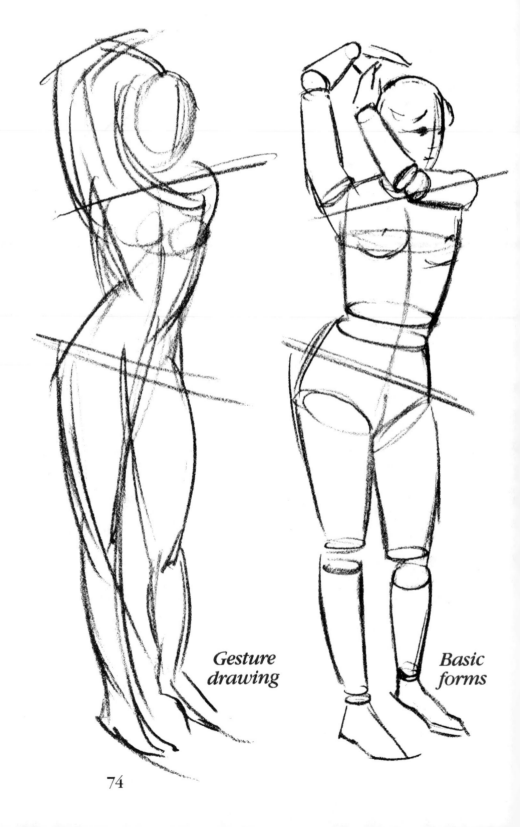

Gesture drawing

Basic forms

Next, lay in the *basic forms*, limb by limb plus neck, head and torso. Check all proportions.

Now flesh out the figure, smoothing, joining and giving it an overall cohesiveness while retaining its femininity.

At this stage, lay in the basic light and shadow pattern from the photo.

Now comes the final version in which you give it your best. Improve and perfect everything you've discovered in the first four drawings. In this instance, eliminate any flaws you've found in the lighting—superfluous wrinkles, etc. Note that the shadow edges on the thighs and breast are wide and soft, while around the bony areas they are crisper and harder. Keep a clear value difference between light and shadow.

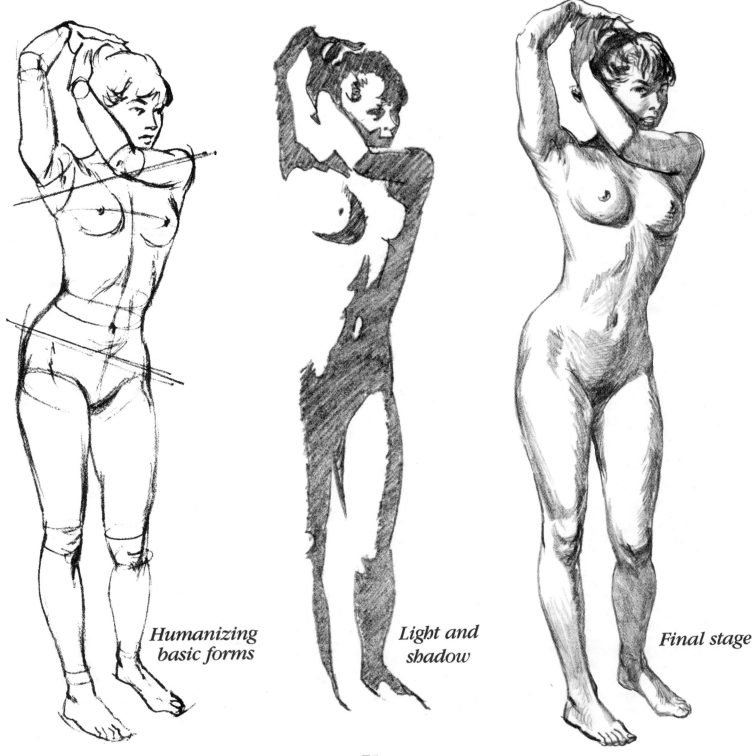

*Humanizing
basic forms*

*Light and
shadow*

Final stage

Drawing the Standing Male Figure

The procedure here for the male figure is the same as for the female. Bear in mind, however, that you must now change mental gears and "think male." Where before, you sought to observe and maintain everything feminine about the figure, you will now do the reverse.

You are now dealing with a huskier frame and a much greater muscular structure; the very pose itself is a male one.

Have the appropriate attitude when you draw either sex.

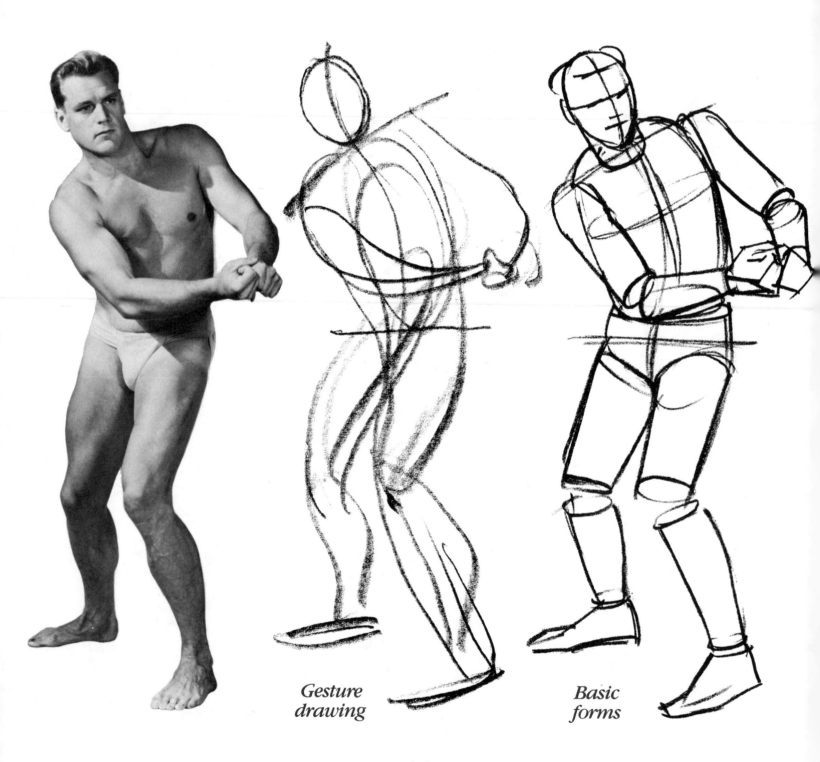

Gesture drawing

Basic forms

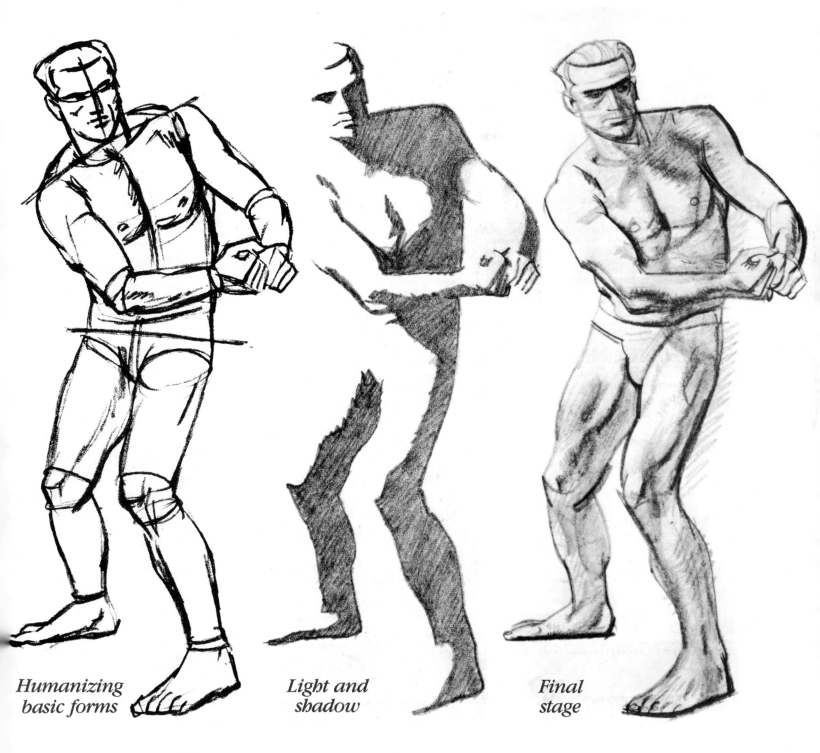

Humanizing basic forms

Light and shadow

Final stage

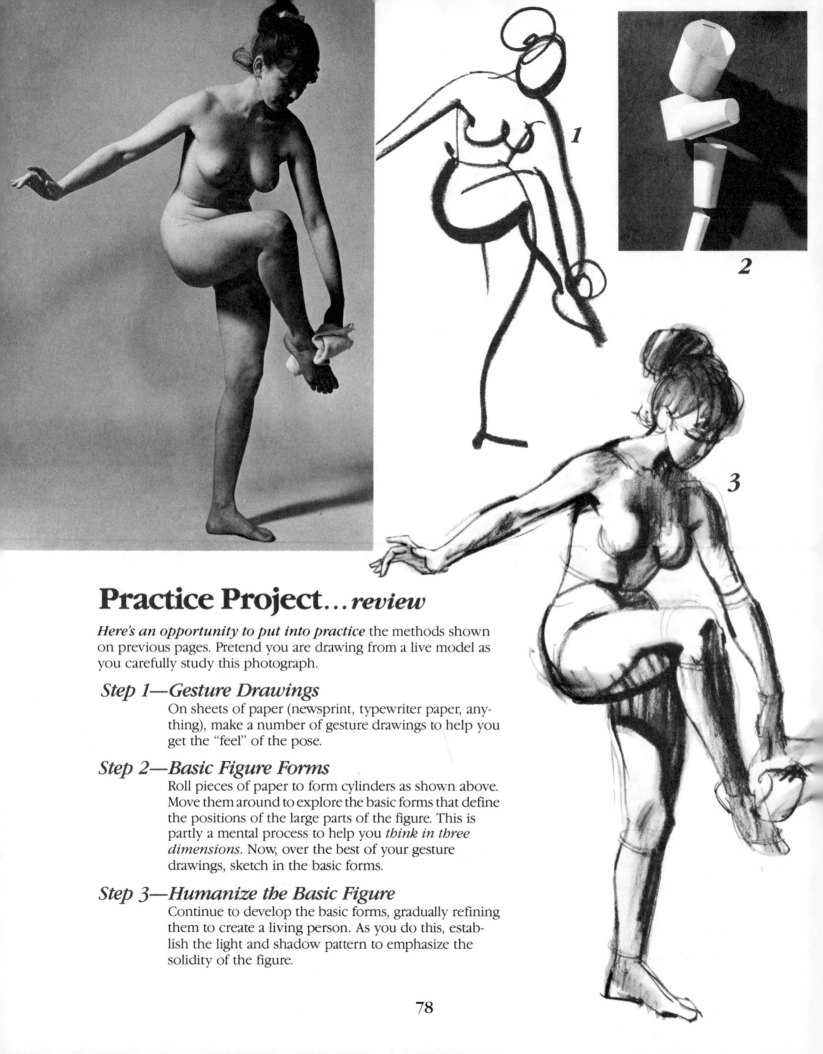

1

2

3

Practice Project...*review*

Here's an opportunity to put into practice the methods shown on previous pages. Pretend you are drawing from a live model as you carefully study this photograph.

Step 1—Gesture Drawings

On sheets of paper (newsprint, typewriter paper, anything), make a number of gesture drawings to help you get the "feel" of the pose.

Step 2—Basic Figure Forms

Roll pieces of paper to form cylinders as shown above. Move them around to explore the basic forms that define the positions of the large parts of the figure. This is partly a mental process to help you *think in three dimensions*. Now, over the best of your gesture drawings, sketch in the basic forms.

Step 3—Humanize the Basic Figure

Continue to develop the basic forms, gradually refining them to create a living person. As you do this, establish the light and shadow pattern to emphasize the solidity of the figure.

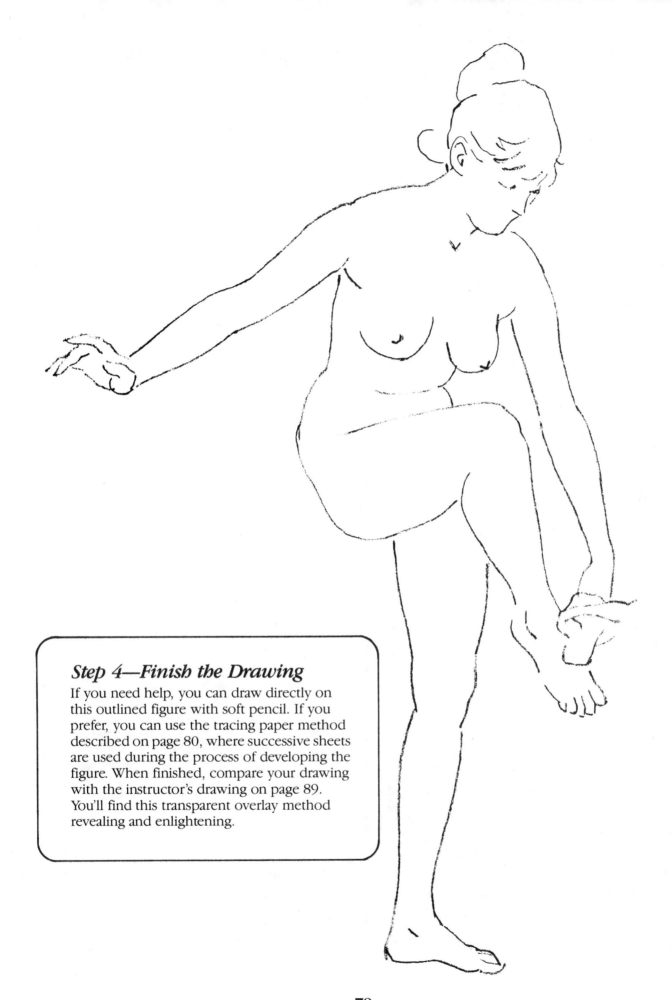

Step 4—Finish the Drawing

If you need help, you can draw directly on this outlined figure with soft pencil. If you prefer, you can use the tracing paper method described on page 80, where successive sheets are used during the process of developing the figure. When finished, compare your drawing with the instructor's drawing on page 89. You'll find this transparent overlay method revealing and enlightening.

Think with Tracing Paper

The beauty of using tracing paper is that it allows you to first make a preliminary trial drawing; then, because it's transparent, you can slip it under a clean sheet and proceed to correct and adjust as you redo the drawing.

You can repeat this as many times as it takes. Be sure, however, that you *don't just mindlessly trace.* Make each successive drawing an improvement, and strive for spontaneity in every new version.

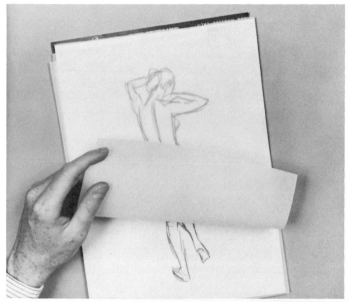

1 *New sheet:* Fasten a sheet of tracing paper over your sketch and do a new drawing, **using your previous one as a** guide and making the necessary improvements.

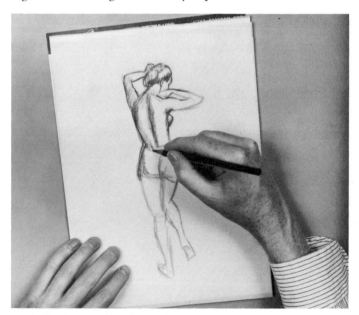

2 *Refining your drawing:* If your drawing needs further adjustments, place a clean sheet of tracing paper over it and continue developing it to the degree of finish you wish.

Transfer with Tracing Paper

It's easy to transfer the outlines of a drawing onto another surface. First, lay a sheet of tracing paper over the picture you wish to duplicate and, with a medium soft pencil, trace the main outlines. Then follow the steps below. If your original drawing was done on tracing paper, as described to the left, just turn it over, blacken the back of the outlines, and trace it down. This method gives you a clean surface on which to work, free from erasures and smears.

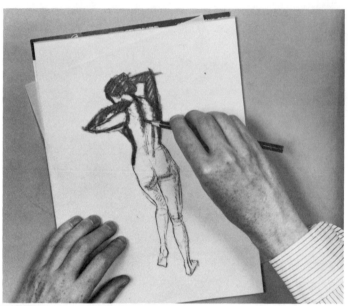

1 *Preparing the back:* Turn your tracing over and blacken the paper right over the back of your traced lines with a soft pencil.

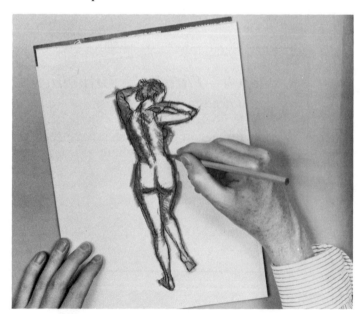

2 *Transferring:* Tape the top corners of your tracing onto the surface on which you plan to draw or paint. With a sharp pencil trace over the outlines and they will be transferred to your drawing surface.

Tracing Papers...*the following pages include these items:*

11 Instructor Overlays. These demonstrations show how instructors at Famous Artists School completed the Practice Projects. Remove them to compare with your own project drawings.

4 blank sheets of tracing paper. These will give you a chance to try out this useful and popular type of paper. Similar paper is readily available at stores selling art supplies.

FREE ART LESSON. This is the most important project of all. You'll find it at the end of the book. Complete it and mail it to get a free evaulation from the instruction staff of Famous Artists School.

TEAR OUT PAGE ALONG THE PERFORATION

More Practice Projects

• Gesture drawings

First review pages 14 through 16. Then start several gesture drawings using the model on page 68. Then turn to page 90 and you'll see sketches made by Famous Artist School Instructors. Compare them with yours.

• Basic form figures

Study pages 22 through 27 and then make basic form figure drawings of the two poses on page 69. Be sure to keep in mind the cylindrical forms as you establish the positions of the various body parts. You'll find drawings by an Instructor on page 91. Tear out that sheet and place it over or beside your drawings for comparison.

• Lighting the figure

After reviewing pages 64 through 67 make drawings of the figures on page 64. First construct the figures using the basic forms. Then place a sheet of tracing paper over your drawing and develop figures with simple light-and-shadow patterns. Now check your results with the Instructor's drawings on page 92.

Note: Slip a sheet of white paper under this page for easy reading.

Tracing Papers...the following pages include these items:

11 Instructor Overlays. These demonstrations show how instructors at Famous Artists School completed the Practice Projects. Remove them to compare with your own project drawings.

4 Blank sheets of tracing paper. These will give you a chance to try out this useful and popular type of paper. Similar paper is readily available at stores selling art supplies.

FREE ART LESSON. This is the most important project of all. You'll find it at the end of the book. Complete it and mail it to get a free evaluation from the instruction staff of Famous Artists School.

More Practice Projects

* **Gesture drawings**

 First review pages 14 through 16. Then start several gesture drawings using the model on page 68. Then turn to page 90 and you'll see sketches made by Famous Artist School instructors. Compare them with yours.

* **Basic form figures**

 Study pages 22 through 27 and then make basic form figure drawings of the two poses on page 69. Be sure to keep in mind the cylindrical forms as you establish the positions of the various body parts. You'll find draw lines by an instructor on page 91. Tear out that sheet and place it over or beside your drawings for comparison.

* **Lighting the figure**

 After reviewing pages 61 through 67, make drawings of the figures on page 64. First construct the figure using the basic forms. Then place a sheet of tracing paper over your drawing and develop lights with simple light and shadow patterns. Now check your results with the instructor's drawings on page 92.

Note: Slip a sheet of white paper under this page for easy reading

Instructor Overlay...*gesture drawing*
For Practice Project on pages 20 and 21.

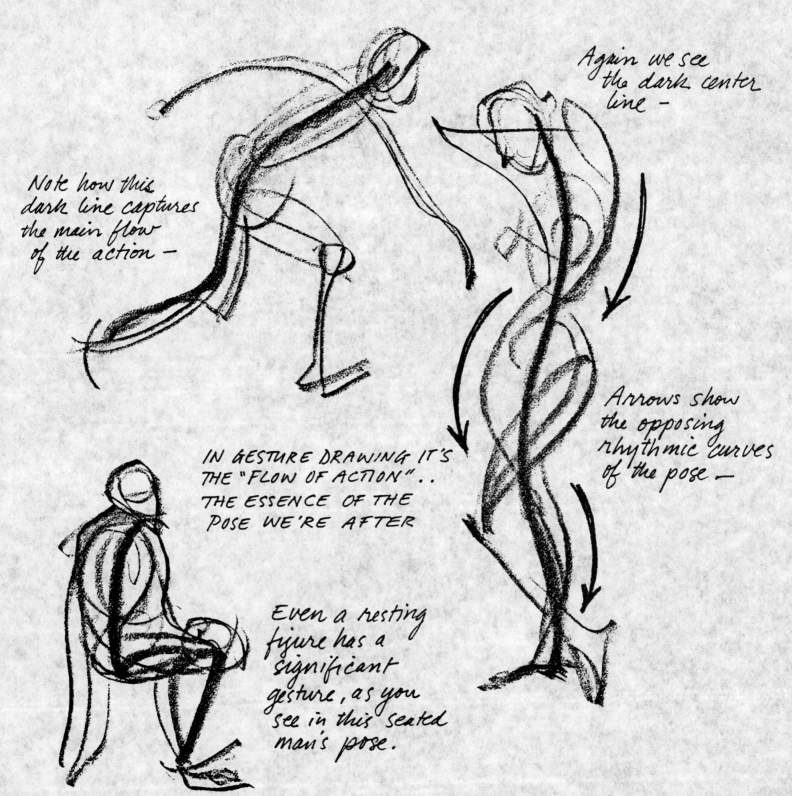

Note how this dark line captures the main flow of the action —

Again we see the dark center line —

IN GESTURE DRAWING IT'S THE "FLOW OF ACTION".. THE ESSENCE OF THE POSE WE'RE AFTER

Arrows show the opposing rhythmic curves of the pose —

Even a resting figure has a significant gesture, as you see in this seated man's pose.

Slip a sheet of white paper under this overlay for easy viewing. You can remove it for comparison with your Practice Project. You'll find these suggestions from an Instructor of the Famous Artists School most helpful.

Slip a sheet of white paper under this overlay for easy viewing. You can remove it for comparison with your Practice Project. You'll find these suggestions from an instructor of the Famous Artists School most helpful.

82

Instructor Overlay…*the basic form figure*
For Practice Project on pages 32 and 33.

When a cylinder form is foreshortened it appears to get shorter, but the WIDTH STAYS THE SAME.

Notice how the upper and lower sections of the torso tilt and twist in different directions.

The arms and legs of the man are good examples of how the figure forms move in and out in space.

This method will help you visualize and draw solid, three-dimensional figures.

Slip a sheet of white paper under this overlay for easy viewing. You can also remove it and place it over your Practice Project for comparison and helpful suggestions from an Instructor of the Famous Artists School.

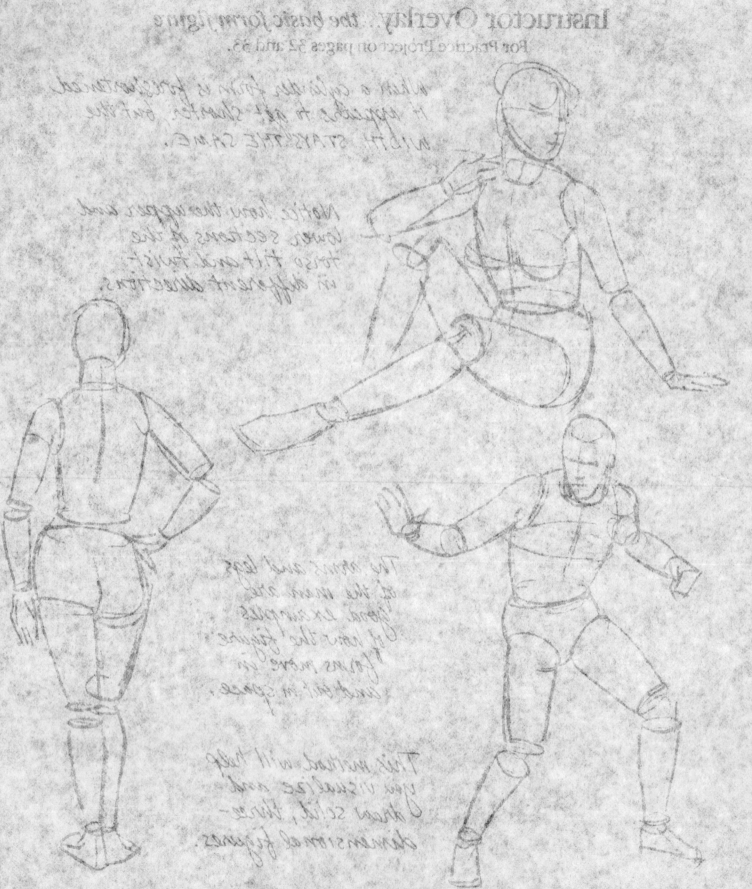

slip a sheet of white paper under this overlay for easy viewing. You can also remove it and place it over your Practice Project for comparison and helpful suggestions from an instructor of the Famous Artists School.

83

Instructor Overlay...*contour drawing*
For Practice Project on pages 38 and 39.

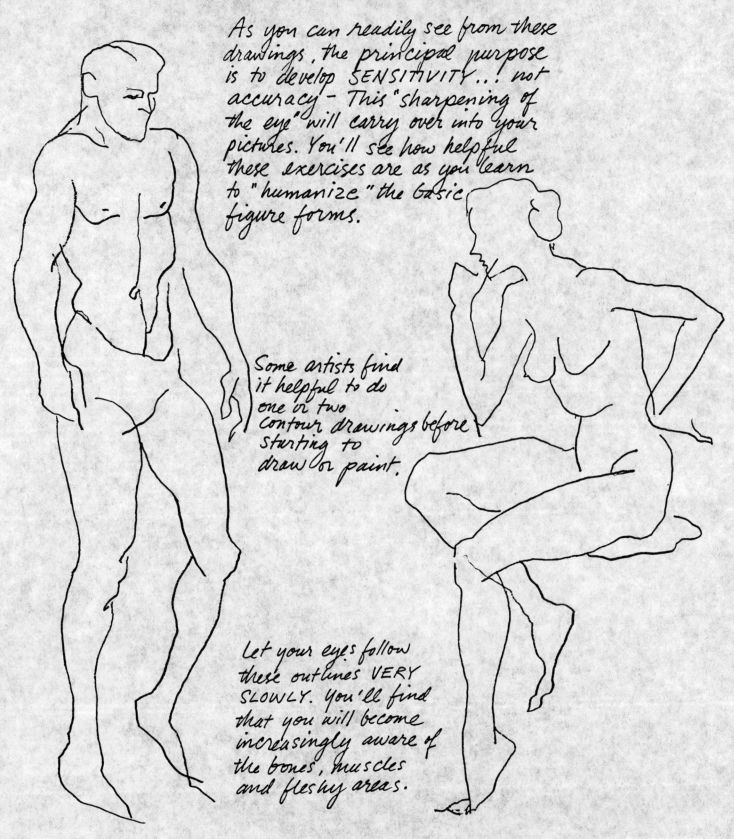

As you can readily see from these drawings, the principal purpose is to develop SENSITIVITY...! not accuracy — This "sharpening of the eye" will carry over into your pictures. You'll see how helpful these exercises are as you learn to "humanize" the basic figure forms.

Some artists find it helpful to do one or two contour drawings before starting to draw or paint.

Let your eyes follow these outlines VERY SLOWLY. You'll find that you will become increasingly aware of the bones, muscles and fleshy areas.

TEAR OUT PAGE ALONG THE PERFORATION

Slip a sheet of white paper under this overlay for easy viewing. You can remove it for comparison with your Practice Project. You'll find these suggestions from an Instructor of the Famous Artists School most helpful.

Slip a sheet of white paper under this overlay for easy viewing. You can remove it for comparison with your Practice Project. You'll find these suggestions from an Instructor of the Famous Artists School most helpful.

84

Instructor Overlay...*form and bulk*
For Practice Project on pages 44 and 45.

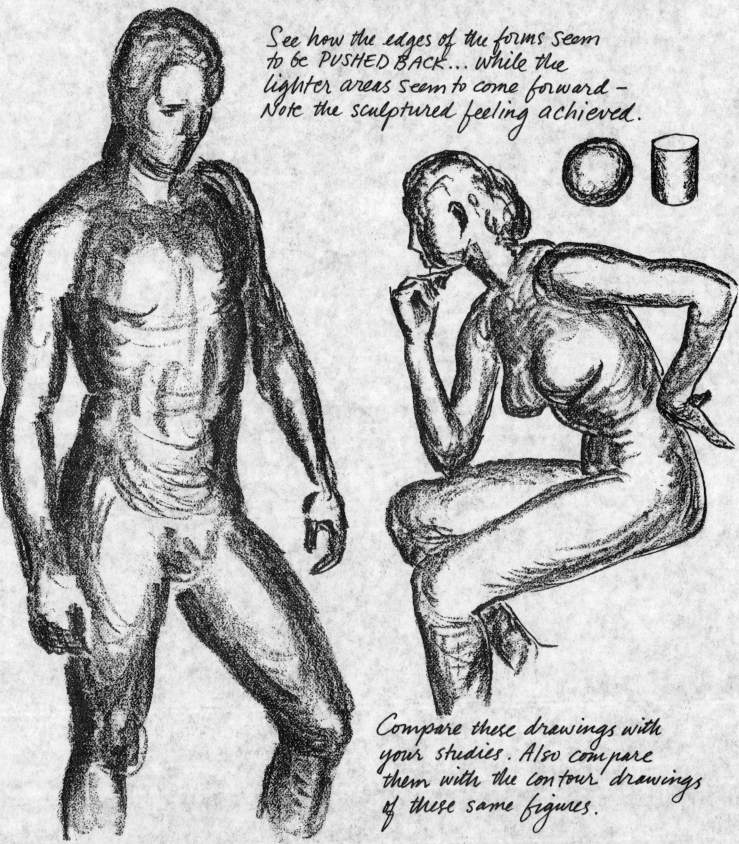

See how the edges of the forms seem to be PUSHED BACK... while the lighter areas seem to come forward — Note the sculptured feeling achieved.

Compare these drawings with your studies. Also compare them with the contour drawings of these same figures.

Slip a sheet of white paper under this overlay for easy viewing. You can remove it for comparison with your Practice Project. You'll find these suggestions from an Instructor of the Famous Artists School most helpful.

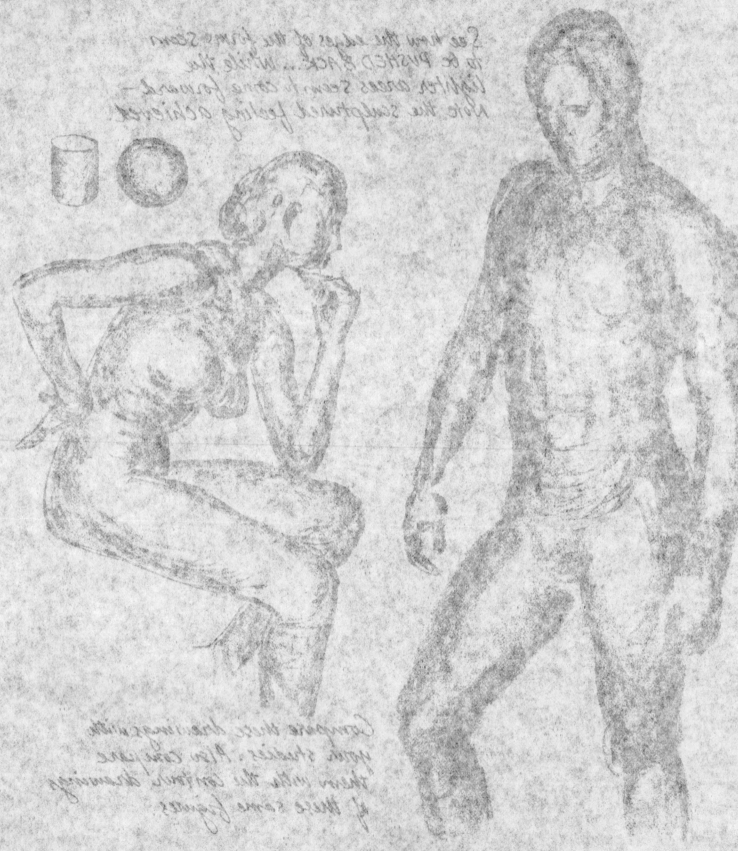

Instructor Overlay...*the skeleton*
For Practice Project on page 58.

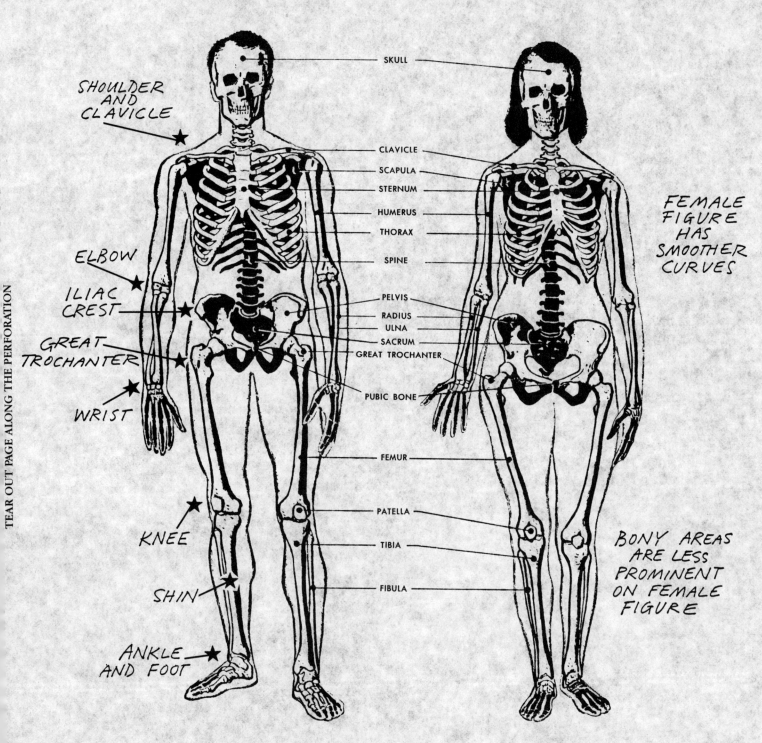

SKULL

SHOULDER AND CLAVICLE

CLAVICLE

SCAPULA

STERNUM

HUMERUS

THORAX

SPINE

ELBOW

ILIAC CREST

PELVIS

RADIUS

ULNA

SACRUM

GREAT TROCHANTER

GREAT TROCHANTER

PUBIC BONE

WRIST

FEMALE FIGURE HAS SMOOTHER CURVES

FEMUR

PATELLA

KNEE

TIBIA

SHIN

FIBULA

BONY AREAS ARE LESS PROMINENT ON FEMALE FIGURE

ANKLE AND FOOT

★ STARS MARK AREAS WHERE BONES ARE NEAR SURFACE AND SHOW PROMINENTLY.

Slip a sheet of white paper under this overlay for easy viewing. You can also remove it and place it over your Practice Project for comparison and helpful suggestions from an Instructor of the Famous Artists School.

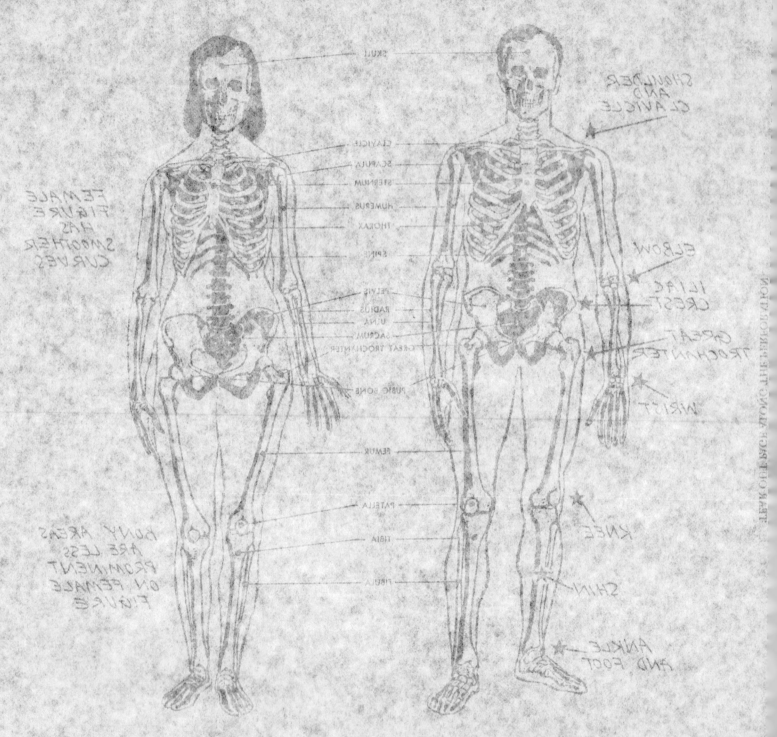

Instructor Overlay... *the muscles*
For Practice Project on page 59.

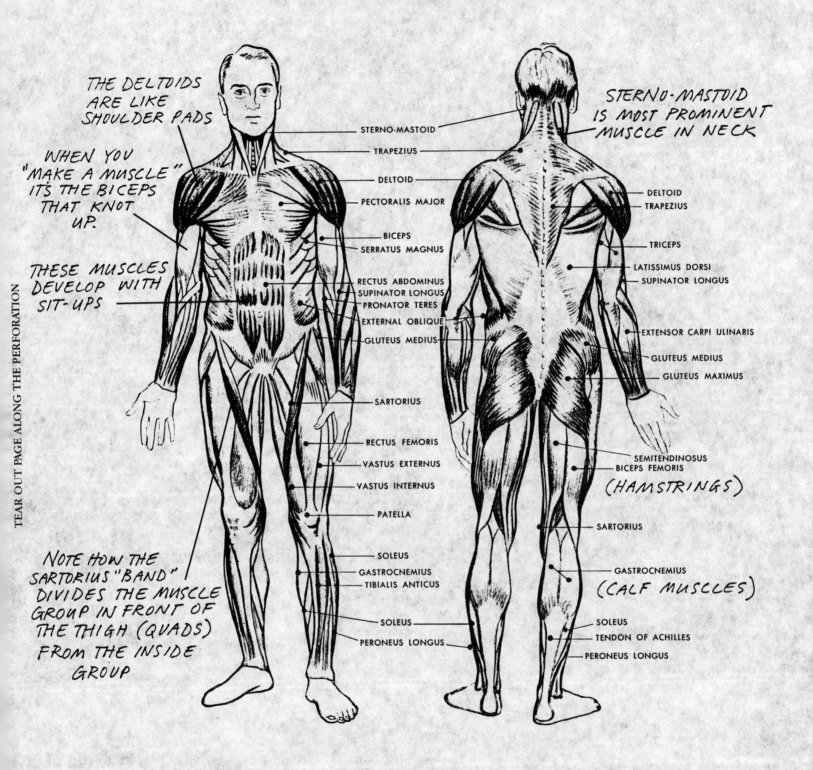

THE DELTOIDS
ARE LIKE
SHOULDER PADS

WHEN YOU
"MAKE A MUSCLE"
IT'S THE BICEPS
THAT KNOT
UP.

THESE MUSCLES
DEVELOP WITH
SIT-UPS

NOTE HOW THE
SARTORIUS "BAND"
DIVIDES THE MUSCLE
GROUP IN FRONT OF
THE THIGH (QUADS)
FROM THE INSIDE
GROUP

STERNO-MASTOID
IS MOST PROMINENT
MUSCLE IN NECK

STERNO-MASTOID
TRAPEZIUS
DELTOID
PECTORALIS MAJOR
BICEPS
SERRATUS MAGNUS
RECTUS ABDOMINUS
SUPINATOR LONGUS
PRONATOR TERES
EXTERNAL OBLIQUE
GLUTEUS MEDIUS
SARTORIUS
RECTUS FEMORIS
VASTUS EXTERNUS
VASTUS INTERNUS
PATELLA
SOLEUS
GASTROCNEMIUS
TIBIALIS ANTICUS
SOLEUS
PERONEUS LONGUS

DELTOID
TRAPEZIUS
TRICEPS
LATISSIMUS DORSI
SUPINATOR LONGUS
EXTENSOR CARPI ULINARIS
GLUTEUS MEDIUS
GLUTEUS MAXIMUS
SEMITENDINOSUS
BICEPS FEMORIS
(HAMSTRINGS)
SARTORIUS
GASTROCNEMIUS
(CALF MUSCLES)
SOLEUS
TENDON OF ACHILLES
PERONEUS LONGUS

Slip a sheet of white paper under this overlay for easy viewing. You can also remove it and place it over your Practice Project for comparison and helpful suggestions from an Instructor of the Famous Artists School.

87

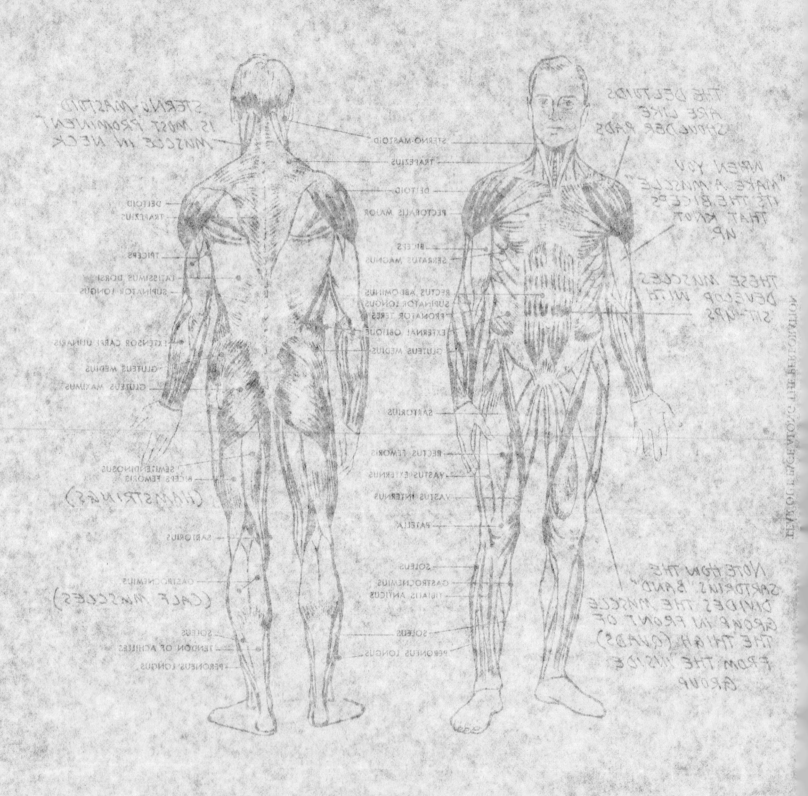

Instructor Overlay
...humanizing basic forms
For Practice Project on pages 62 and 63.

USING YOUR KNOWLEDGE AND OBSERVATION OF THE STRUCTURE OF THE HUMAN FIGURE YOU CAN MODIFY THE BASIC FORMS TO ACHIEVE A CONVINCING, REALISTIC FIGURE.

Observe how the muscles of the arms and shoulders can be indicated

Note how the flow of muscles and fleshy areas has been achieved.

The simple cylinder-like basic forms are modified, without losing their solid structure... the forms must still go in out in space.

Slip a sheet of white paper under this overlay for easy viewing. You can also remove it and place it over your Practice Project for comparison and helpful suggestions from an Instructor of the Famous Artists School.

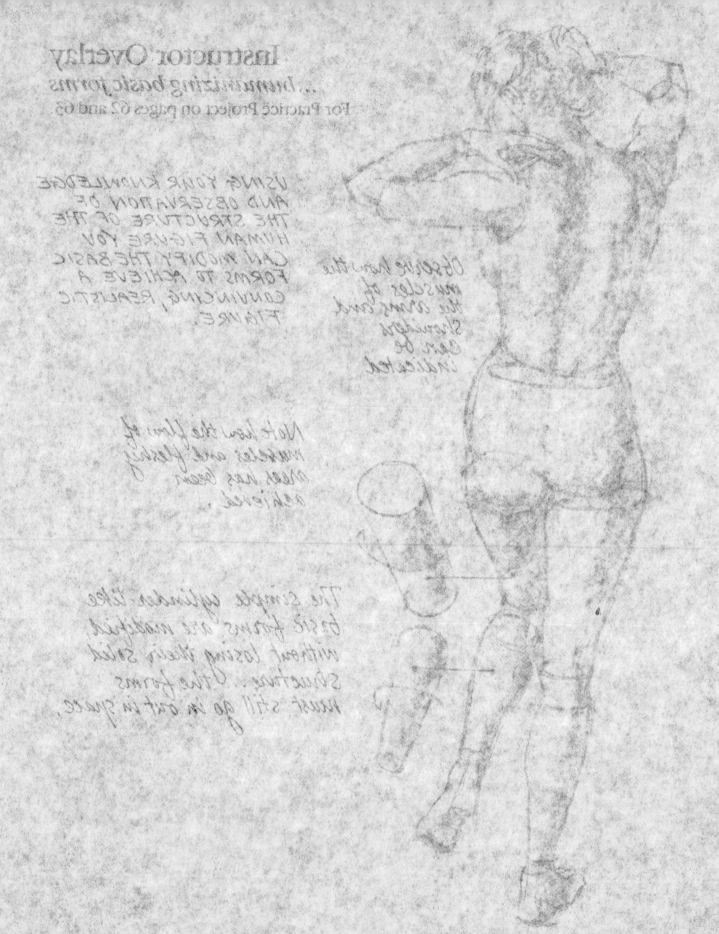

Instructor Overlay
...humanizing basic forms.
For Practice Project on pages 62 and 63.

USING YOUR KNOWLEDGE AND OBSERVATION OF THE STRUCTURE OF THE HUMAN FIGURE YOU CAN MODIFY THE BASIC FORMS TO ACHIEVE A CONVINCING, REALISTIC FIGURE.

Observe how the muscles of the arms and shoulder can be indicated.

Note how the flow of muscles and gesture has been achieved.

The simple cylinder-like basic forms are modified without losing their solid structure. The forms must still go in-out in space.

Slip a sheet of white paper under this overlay for easy viewing. You can also remove it and place it over your Practice Project for comparison and helpful suggestions from an instructor of the Famous Artists School.

88

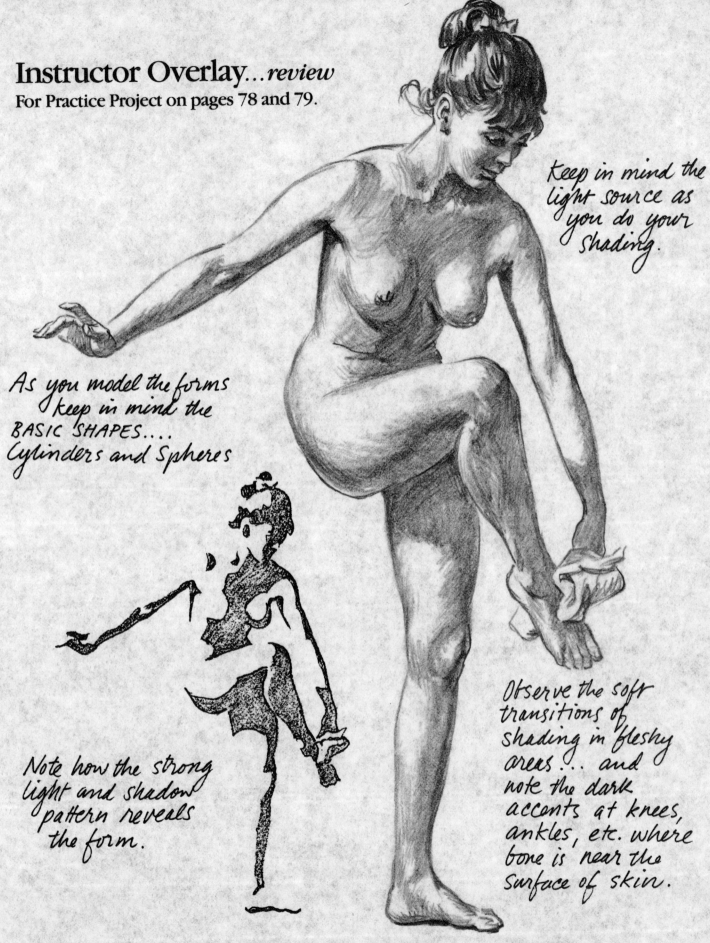

Instructor Overlay...*review*

For Practice Project on pages 78 and 79.

Keep in mind the light source as you do your shading.

As you model the forms keep in mind the BASIC SHAPES.... Cylinders and Spheres

Note how the strong light and shadow pattern reveals the form.

Observe the soft transitions of shading in fleshy areas... and note the dark accents at knees, ankles, etc. where bone is near the surface of skin.

Slip a sheet of white paper under this overlay for easy viewing. You can also remove it and place it over your Practice Project for comparison and helpful suggestions from an Instructor of the Famous Artists School.

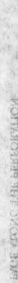

Slip a sheet of white paper under this overlay for easy viewing. You can also remove it and
place it over your Practice Project for comparison and helpful suggestions from an Instructor
of the Famous Artists School.

89

Instructor Overlay...*gesture drawing*
For Practice Project on page 81.

DO MANY
RAPID SKETCHES
TO CAPTURE THE
FLOW OF ACTION

With her weight
poised on her
toes, she throws
her head back
for balance

Arrow shows
how the action
pulls through
the body to the
raised knee.

QUICK PEN
GESTURE SKETCH -
TRY THIS WHEN
LOOKING AT SPORTS
ON T.V.

Slip a sheet of white paper under this overlay for easy viewing. You can also remove it and place it over your Practice Project for comparison and helpful suggestions from an Instructor of the Famous Artists School.

Slip a sheet of white paper under this overlay for easy viewing. You can also remove it and
place it over your Practice Project for comparison and helpful suggestions from an instructor
of the Famous Artists School.

90

Instructor Overlay...*basic form figure*
For Practice Project on page 81.

Keep in mind how the cylindrical forms point in different directions

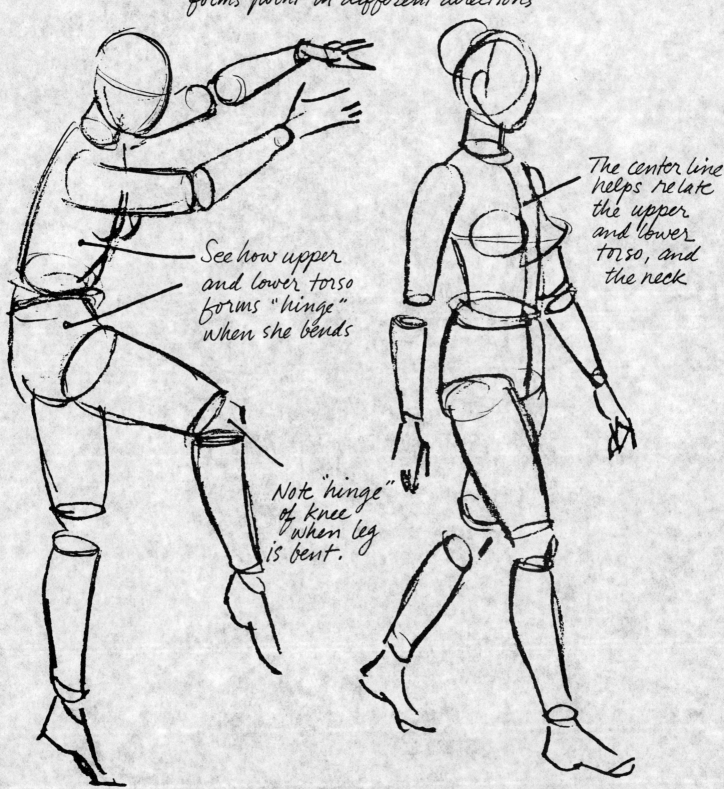

See how upper and lower torso forms "hinge" when she bends

The center line helps relate the upper and lower torso, and the neck

Note "hinge" of knee when leg is bent.

Slip a sheet of white paper under this overlay for easy viewing. You can also remove it and place it over your Practice Project for comparison and helpful suggestions from an Instructor of the Famous Artists School.

Slip a sheet of white paper under this overlay for easy viewing. You can also remove and place it over your Practice Project for comparison and helpful suggestions from an instructor of the Famous Artists School

97

Instructor Overlay...*lighting the figure*
For Practice Project on page 81.

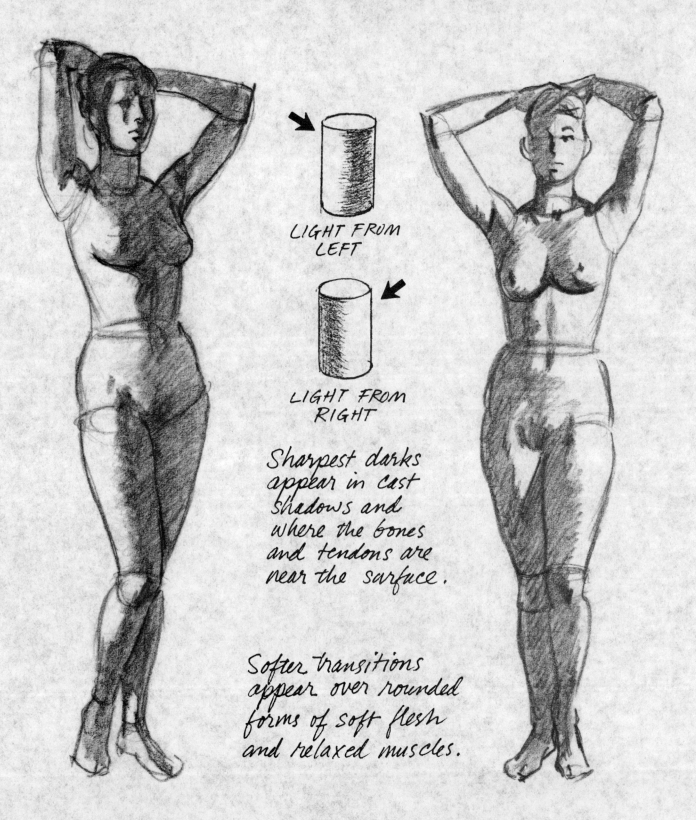

LIGHT FROM LEFT

LIGHT FROM RIGHT

Sharpest darks appear in cast shadows and where the bones and tendons are near the surface.

Softer transitions appear over rounded forms of soft flesh and relaxed muscles.

Slip a sheet of white paper under this overlay for easy viewing. You can also remove it and place it over your Practice Project for comparison and helpful suggestions from an Instructor of the Famous Artists School.

Tracing Paper. These sheets will give you a chance to try out this useful and popular type of paper. Similar paper is readily available at stores selling art supplies.

Tracing Paper. These sheets will give you a chance to try out this useful and popular type of paper. Similar paper is readily available at stores selling art supplies.

Tracing Paper. These sheets will give you a chance to try out this useful and popular type of paper. Similar paper is readily available at stores selling art supplies.

Tracing Paper. These sheets will give you a chance to try out this useful and popular type of paper. Similar paper is readily available at stores selling art supplies.

Tracing Paper. These sheets will give you a chance to try out this useful and popular type of paper. Similar paper is readily available at stores selling art supplies.

Famous Artists School
invites you to enjoy this valuable FREE Art Lesson

Just complete this FREE Art Lesson using your own natural talents and what you have learned from this step-by-step method book. The Lesson covers several areas of artistic development. Then fill in the information on the reverse side, fold as indicated and mail to Famous Artists School. A member of our professional Instruction Staff will personally evaluate your Special Art Lesson and return it to you with helpful suggestions. You will also receive information describing the complete Famous Artists School courses which will open up a world of personal satisfaction and creative achievement for you. No obligation—this personal evaluation and information are yours absolutely free. Don't miss this important opportunity—mail this valuable Art Lesson today.

DETACH HERE

Picture composition...how shapes fit together

- All pictures are composed of shapes. Objects in a picture are called positive shapes. The remaining areas are negative shapes. Indicate the total number of separate shapes, both positive and negative, that you see in the design at right.

 In this example there are two shapes

one two three four five six

Observation...part natural and part learned

- On a bright, sunny day, the color of green leaves on a tree looks
 - a) yellow-green in sunlight and blue-green in the shadows
 - b) blue-green in sunlight and yellow-green in the shadows
 - c) the same in sunlight and shadow

- Which triangle appears closest to you?

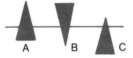

- Half close your eyes as you look at these four panels. While squinting, which one appears to be the darkest?

A B C D

Lighting...shadow pattern reveals form

- Diagram A shows the way the shadows would look if there was one light source as shown. Using a pencil or pen, shade in how the shadows would fall on Box B with the same light.

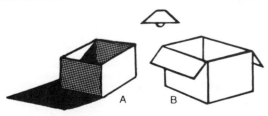

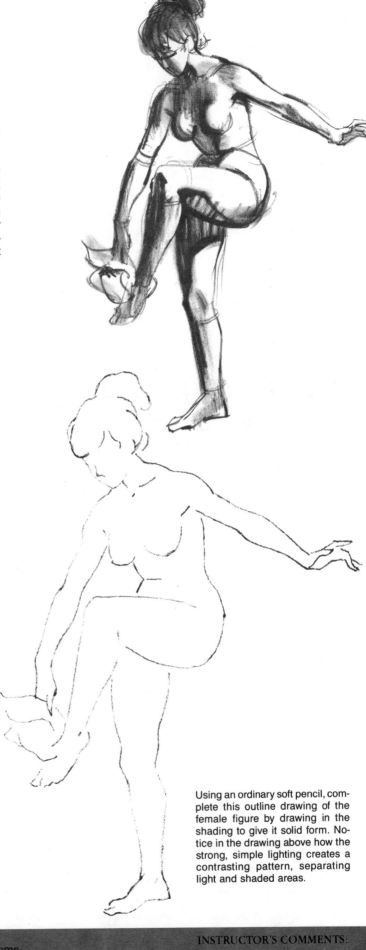

Using an ordinary soft pencil, complete this outline drawing of the female figure by drawing in the shading to give it solid form. Notice in the drawing above how the strong, simple lighting creates a contrasting pattern, separating light and shaded areas.

INSTRUCTOR'S COMMENTS:

Like to Learn More About Drawing the Human Figure?
You can…with Famous Artists School's time-tested method.
Get started today with this valuable art lesson.

THIS OFFER IS AVAILABLE ONLY IN THE UNITED STATES AND CANADA.

This side out for mailing. Fold in half along broken line.

Mr.
Mrs.
Miss_____
Ms
Address _____ Apt. No. _____

City_____ State _____ Zip_____

Telephone Number___()_____
 (area code)

FAMOUS ARTISTS SCHOOL
Dept. FF1
17 Riverside Avenue
Westport, CT 06880

First Class Mail

ATTENTION:
Instruction Department
FREE ART LESSON